88 Secrets to Selling & Your Photography

by
Scott Bourne

First Edition

Second Printing

Olympic Mountain School Press - Gig Harbor, Washington

88 SECRETS TO SELLING & PUBLISHING YOUR PHOTOGRAPHY

By Scott Bourne

Cover Design By Denise Knudson and Scott Bourne
Cover Photographs Copyright Scott Bourne, 2002, 2003, 2004
All Rights Reserved

Book Design And Layout By Denise Knudson
Book Editor Jana Bourne

LCCN: 2004114837

First Edition

Published by Olympic Mountain School Press
P.O. Box 1114
Gig Harbor, WA 98335
253-858-4448

www.mountainschoolpress.com

Copyright 2005, Olympic Mountain School Press

First Printing 2004
Second Printing 2005

Printed in the United States of America

ISBN# 0-9761878-0-9

DEDICATION

This book is dedicated to the dreamers.

TABLE OF CONTENTS

List Of Illustrations

FOREWORD

Let me just say this right at the beginning: Scott Bourne is a marketing wizard. For those of you who are the skeptical types who disdain hyperbole, I will say it again in a more believable way: Scott Bourne is a marketing wizard!

Now that we have that is out of the way let me get right to the biggest complaint I have about *88 Secrets To Selling & Publishing Your Photography*, and it is a big one. There are far more than 88 secrets in this book. The book should really be called "2000 Secrets." Scott delivers on his promise to share the secrets of the pros in a big way.

Fair warning though...when you read *88 Secrets To Selling & Publishing Your Photography,* your mind is going to fill up quickly. For those of you who are just beginning to market your work, you'll find yourself thinking: "That's a good idea: I gotta try that." For those of you who have already started publishing and selling images, you'll find yourself thinking: "I've been meaning to do that." or "Why didn't I think of that?"

Either way, no matter where you stand on the road to photographic fame and fortune, you'll find this book extremely helpful. I know this because I have been a successful professional photographer for twenty years. And I found some really good ideas on every page. This book is going to help me be even more successful in my next twenty years!

Just remember that buying and reading *88 Secrets To Selling & Publishing Your Photography* will only be helpful if you actually go out, take the initiative and be persistent. Initiative and persistence are the two primary traits that will determine success or failure in any undertaking. So go out and try and then try again. You might surprise yourself.

Of course, trying and trying again is a lot more successful when you have a copy of Scott's book. I wish I had one twenty years ago.

David Middleton - Danby, Vermont

INTRODUCTION

Great photographs, really great ones, evoke emotion and generate dialog. But if a great photograph isn't shared, it can't really tell a story.

I believe that the art of photography lies in its ability to stimulate thought and conversation. Of course, storytelling requires two parties: A person to tell the story and a person to listen to the story. Publishing, selling or distributing a photograph creates a second link in the chain. The photographer is the picture maker and storyteller. The people who see that photo get to learn your story. If your story is moving and compelling and it causes others to feel, think or react, then you've established a dialogue. For many, the dialogue is enough. That's where publishing comes in. Publishing is sometimes its own reward. When you publish in a book or magazine or a newspaper, you get the reward of knowing that your vision, your idea, your story, was transmitted to others. They got to see things the way that you saw them.

But some photographers need to get paid for their photos. If you can sell someone a photo, that is the ultimate photographic compliment. When someone says they want to buy a print or license an image, then you have not only communicated with someone, but you have communicated in a way that is so successful that they are willing to give up money for it. That's a real high.

The goal of this book is to help photographers achieve that high. It's not easy to sell and publish your photos. But if you apply the secrets shared in this book and work harder than the next person, there is a real chance that you can succeed.

Scott Bourne
Gig Harbor, Washington

October, 2004

ACKNOWLEDGEMENTS

This book represents not only my work, but the work of friends, colleagues and students who graciously gave of their time to read, review and make edits.

First thanks go to my wife, Jana, for being a constant source of support. Thanks also to Jana for her editorial expertise. Her experience and guidance have turned me into a writer.

Thanks to Carolyn Wright for her editorial revisions and for providing legal services to this project. Carolyn is an all-star litigator and lawyer and if you need legal assistance, I highly recommend her. Visit Carolyn's web site at www.photoattorney.com.

Thanks to Robin Bartlett for his amazing expertise in all things publishing. His editing, research, contacts and support made this book better than I thought it could be. If you ever need help with a publishing project, call Robin.

Robin Bartlett - Bartlett & Associates
General Publishing Consulting (Non-Fiction)
63 Burlington Street
Norwood, NJ 07648
201-315-5400
www.robinbartlett.com
rbbartlett@aol.com

Thanks to David Middleton who has been a good friend, editor and source of ideas and information. Thanks also to David for writing the Foreword. David's web site is at www.davidmiddletonphoto.com.

Thanks to my friends and colleagues who added their comments to the jacket cover.

Thanks to the Publishers Marketing Association.

Thanks to the students at Olympic Mountain School of Photography and to Olympic Mountain School Press for publishing this book.

"Leap, and the net will appear."

-<u>John Burroughs</u>

HOW TO USE THIS BOOK

You should think of this book as your personal idea generator. Every secret I reveal is brief and to the point. I've written the book that way for a reason. My aim is to spur you to take action.

You should take these secrets and run with them. Flesh them out. Put your own spin on them. Turn them inside out. Apply your own style and extend them further than I have or in a completely new direction. But, above all, take action! The secrets in this book are useless without action and implementation by you.

Promise yourself right now to read and take action on at least two of these secrets every week.

You don't have to read this book from front to back. Feel free to skip around. There are three sections to this book: *General* secrets that will be useful to everyone. *Publishing* secrets for those who want to get their images published and *Sales* secrets for those who want to sell their photographs.

Read my secrets in any order you like. The important thing is to look at each and every one of the secrets over time, decide how they can work for you and implement them.

And here's the best secret of all: *If you believe in yourself, you will be able to accomplish any goal you set!* This book will become your best friend in that process if you believe that you can master and employ these techniques to be successful. Think deeply and focus on using each secret to mold your market or style. If you think a secret doesn't apply to you, change it around, take a different snapshot of it, look at it from a different perspective, and bend the idea until it does.

Other books by Scott Bourne
88 Secrets to Photoshop for Photographers

SECTION ONE – GENERAL SECRETS

SECRET #1: COMMITMENT TO MARKETING

Commit to marketing your work. It takes time to develop any new business, and it takes time to develop a reputation in the photo world. Commit time to selling and showing your photographs. If you want to be a rock star you have to put your time in as a roadie before you get to play the big concerts. The same is true for photography. So, plan for the long term.

Fundamentally, you must be committed to your work. You must be patient and persistent. You must believe in your photos and the quality of your work. And you must plan to spend time each day selling and showing your work.

Remember that selling your work is YOUR responsibility. No one else is going to do it for you (unless you have hired an agent). Promoting your work is your primary job if you want to sell or publish your photos. The images themselves are secondary to that simple objective. Commitment is the true secret behind successfully marketing your work.

SECRET #2: SHOW YOUR WORK

If your only accomplishment in reading this book is to understand this secret, then the book has paid for itself. Showing your work is crucial. It's the first step toward establishing your ability to publish and sell.

It's important to show your work to anyone and everyone who will look at it. If people don't know what you have for sale, how can they buy it? Don't rely on extra sensory perception. You have to show the work to sell it.

Show the kind of work you want, like and do best. If you are a wedding photographer, put together an album (portfolio) of your best wedding shots. If you want to sell commercial product shots, assemble a product portfolio. If you want to sell your work as art, you must present it as art.

While this SHOW THE WORK theme may seem fundamental, many photographers fail to understand it and never achieve success. The more you show your work, the more you will sell. This means that you must enter art fairs and contests, post it on websites, publish articles, present community slide shows, hang your images in coffee shops, offices and yes—even in galleries.

What's more, you must make or create opportunities to show your work. Offer to illustrate books for local authors in return for photo credit. Rent space at street fairs and display your images. Send copies of your portfolio to professional designers and decorators and ask them to use your photographs when they create displays. Mail post cards featuring your work to local restaurants and gift shops and ask them to display and sell your work. Try to barter for wall space in places where the public will see your work, such as local banks, businesses, and restaurants.

If you want to sell your photographs, you need to budget half your day to salesmanship. That means writing letters, making phone calls, and knocking on doors to get your work seen. If the quality is there, someone will eventually want to buy it. But people can't buy what they don't see. So commit to practicing Secret # 2 and show your work, show your work, and then show it some more.

SECRET #3: PORTFOLIO REVIEW EVENTS

Portfolio review events are an opportunity for emerging photographers to get exposure with photo buyers, museum and gallery curators, book publishers, and photo editors. These events are held throughout the country as a way for buyers and publishers to discover new talent. There is usually a fee to participate.

When a review event presents itself, plan to show only your best work. Display your work in the most flattering way. Bring business cards and be prepared to discuss your images in depth. This type of event is a sort of job fair for photographers. Be forewarned, however, portfolio review events are usually packed with aspiring photographers. Reviewers will select only the very best images.

You can search the Internet for portfolio review events, but here is a partial list of some of the best-known ones throughout the country.

Review Americas, Portland, Oregon, is held on odd-numbered years. This is one of the best portfolio review events in the country. It's really a photo festival and road show all rolled into one. www.photoamericas.com.

FotoFest/The Meeting Place, Houston, Texas, is held on even-numbered years. It is the biggest portfolio review event held in the USA. www.fotofest.org.

Review Santa Fe, Santa Fe, New Mexico, is held every summer. This is a juried portfolio review where you have to submit slides and request an invitation to participate. www.photoprojects.org.

SECRET #4: ENTER PHOTO CONTESTS

By now you have noticed the recurring (and thus important) theme of SHOW YOUR WORK, so, don't forget contests.

If you want to publish your photographs, contests can be a great way to get started. Many contests offer both publication and cash or prizes as awards. More importantly, they give your work added exposure. If you enter the right contests, you can even get national exposure.

In 1996, I won second place in *the Popular Photography International Picture Contest*. That award gave me a newsworthy opportunity to send out a press release. It gave me a stellar photograph to frame and hang on the wall of my studio for prospective customers and students to see. I received dozens of calls requesting the right to license the photo and requests to purchase prints.

Contests are usually free or very inexpensive to enter. To find contests, go to Google and search for "photo contests." Stand back because there will be thousands. Try to enter national contests as often as you can. Any contest that includes printed or published exposure of the prize-winning photos is worth considering.

Sometimes your award will be prize money or national publication. Even if there is no money, winning a photo contest can bring you tremendous benefits. And even if you don't win a top prize, the experience will be valuable the next time you enter. Above all, you also get to see how your work compares with your peers.

There are a few caution points to remember when you enter contests. Remember that some contests require you to give up all the rights to your image. I would avoid those contests. Some contests won't return the images you send so only send copies.

My winning shot in Popular Photography – Flowering By Myself

SECRET #5: MAILING LISTS

The right mailing lists can end up being worth more than the value of your camera. If someone publishes, licenses, displays, purchases, prints, rents, leases, distributes or otherwise buys your photos, you should add this person to your mailing list. A good, clean mailing list full of customers that have purchased your work is a formidable marketing tool. Be sure to keep a second list of good prospects as well in case you want to run additional promotions for new business.

Typically, the old 80-20 rule applies: 80 percent of your sales will come from 20 percent of the people on this list. So treat this list with great respect. Keep it clean. If you get a misdirected piece of mail (i.e., a nixie), remove that name from the list or enter the correct address if it's available. Immediately enter changes of address as you receive them, and if you send mail to someone for two years and they fail to respond, remove them from the list (or send them a note telling them this is their last piece unless they respond).

It's always much harder to find a new customer than it is to work with an existing one. So, send promotion pieces to your in-house mailing list on a regular basis and keep your clients informed of what you are doing. And certainly, a web site showing your best work is mandatory.

If you are just starting out, you can buy mailing lists. InfoUSA (www.infousa.com) is a good place to start. Over time, you will be able to supplement the names you buy with names you have acquired through personal interaction.

SECRET #6: COMMUNICATION TIPS (PART 1)

The best photographers have to be accessible. There is nothing more frustrating for an editor or photo buyer than not being able to reach a specific photographer when they need to. Put yourself in their shoes. They discover this great image that they want to use, but they can't get in touch with the photographer who made it. So, they give up and accept a mediocre alternative from a photographer who can be contacted.

Always include your physical mailing address, your post office box, your business and cell phone numbers, 800 number, fax number, e-mail address and web site address on every photo, every marketing piece, web site, and any other material you produce. (On slides, your name and phone number will suffice.) If you don't have a business mailing address, you should obtain a post office box. If you don't have a fax machine, you can get a virtual fax number. Do whatever is necessary to help clients to find you easily and rapidly by any means they desire: phone, fax, e-mail or snail mail.

Here's a list of companies to contact is you want to order an inexpensive nationwide, toll-free number:

AT&T 800-222-0400
MCI 800-777-1099
TELCOM USA 800-866-3322
SPRINT 800-366-1046

SECRET #7: COMMUNICATION TIPS (PART 2)

If you truly want to be a professional photographer, you must have a dedicated telephone line for your business. People will spend $30,000 on photo gear but they are afraid to spend $30 a month on a business telephone line.

Photography is a very competitive marketplace. Anyone can buy a camera. And since everyone thinks they are a photographer, professional presentation is the thing that helps separate amateurs from working professionals.

Answering the phone in a professional manner will build your clients' confidence. Having a business line with a listing in directory assistance and the Yellow Pages says that you are committed to your business.

If you have a home office, make sure to instruct family members how to answer the phone. But, preferably, have your business line restricted to your own personal control or use voice mail. Avoid allowing children (or teens for that matter) to answer your business telephone. A voice mail service for less than $15 per month from

most telephone companies allows you to receive messages while on the line. Alternatively, you can also buy an answering machine for less than $30, but you will lose the capability to take messages while on the phone.

Make sure that your phone message is recorded in the name of your business. Here's a sample way to answer professionally. *"You have reached Joe Smith Photography. Thanks for calling. We're sorry, but we are away from the office or on another line. Please leave your telephone number and name, and we will return your call as soon as possible."*

A business telephone line will pay for itself in many ways. First, it will encourage clients to do business with you. Having a business line also leaves your home number free to do things such as sending faxes, accessing the Internet or making personal calls. Perhaps the best benefit to having a business line is that you get a free Yellow Pages listing with your business telephone number. This helps clients find you. In some cities your listing will even include your street or web address. And, you can investigate placing an ad in any category of your choosing. Your free business line listing is a first step toward becoming a published and paid professional photographer. This means you are serious about your work and ready to do business. One good client each year will pay for the phone line expense.

By the way, in some cities you can enhance your free listing by including your website URL. It's well worth making this investment. This turns your business telephone line listing into a multi-page promotion as clients are referred to your website. You can include much more information about your services online than you can in a phone book or advertisement.

And here's a tip on saving money on your business telephone line. If you don't actually need to talk on that telephone line, but you just want to have a business phone number that is listed in the local directory assistance and the Yellow Pages, call your phone company and tell them you want a "software only" business line. You will pay as much as 45 percent less compared to the cost of a physical line. You will also save on installation costs. These lines work by ringing

to voice mail systems only. You are responsible for checking the voice mail on a regular basis and then calling the customers back. Thus, you get many of the same the benefits of a business telephone line, but you can't make outgoing calls from this line.

SECRET #8: CREATE CUSTOMERS

Experts agree that it can cost ten times as much to acquire a new customer as it does to retain a current customer who has already done business with you. So it's important to pursue new business from existing customers.

It's a basic rule of business that customers usually do business with people they like and trust. It's also true that regular customers often spend more than casual ones. Regular customers exhibit loyalty to the people who take time to get to know them and cater to their needs. If they are rewarded with the extra attention and service they desire, regular customers are willing to pay more for the pictures they want and provide you with referrals.

Keep these facts in mind when you are communicating with photo buyers and publishers. Don't be difficult to negotiate with. Responding negatively or with poor service is likely to have a negative impact on your reputation. Try to respond positively to all reasonable requests by your customers. One of the best techniques is to respond to inquiries immediately. If you don't, it's likely that customers will find another photographer who will.

Referrals among publishers are common. Editors of leading magazines know and network with each other. If they like you and your work, they will "pass you on within their network." It's only natural that people will want to work with someone who has a solid reputation. Build one.

SECRET #9: SELF-PROMOTION MATERIALS

If you want to get paid for your photos, you have to identify and promote to the publications that are likely to publish your work. You need to submit materials to these publishers at least once every quarter. The most cost effective way to do this is with postcards.

Choose your most compelling image and print it on a post card. Then, send it to every editor you want to shoot for. Include a snappy headline or caption on the back along with your name, address and phone number.

In addition to post cards, you should publish in resource or stock books. If you want to shoot weddings, you have to be in bridal catalogs. In short, where do buyers you want to reach look for fresh photography? That's where you have to be.

Start with a combination of advertising, direct mail, e-mail, phone calls and faxes. And you need to use several types of communication because everyone has their favorite way to be contacted. Some prefer phone and fax, others work via e-mail only, and others prefer the U.S. Mail. You have to employ all of these media to make certain that your message gets through.

Depending on the kind of photography you want to do, you can launch a self-promotion campaign for as little as a few hundred dollars. However, if you want to do fashion or one of the other high-end photographic pursuits, prepare to spend thousands of dollars on promotion. Your competitors are already spending that much and more. You will have to spend an equal amount in order to remain competitive.

If you persevere and promote your work on a regular basis, you will eventually impress your prospects as professional, dependable and hard working. This is the door opener you are looking for.

Find Out Why This Bride Is Smiling!

Meet Tammy and other Scott Bourne brides at the
Scott Bourne Photography Studio Open House
Friday, February 1, 2002 4-6 PM refreshments/music/fun

Scott Bourne Photography
3206 50th ST CT NW Suite 105C
Gig Harbor, WA 98335
253.851.6004

Sample Self Promo Piece

SECRET #10: GOOD EDITING

When it comes to selecting the best photos to show buyers and publishers, most photographers show far too many images. What's worse, many of the images they end up selecting are not their best

The first rule of good editing is be brutal. If there is even ONE thing you don't like about a particular photo, don't include it in your portfolio. Editors are accustomed to looking at only the very best images. Good images will not be good enough to compete. So, choose only your very best work.

Narrow your images down to 25 and then, narrow them down again. To finish the job, pay a consultant to critique your work. After explaining the target audience for your images, ask the consultant, "Are these the right photos to show?" Then listen to their advice

Most photographers have great difficulty in editing their own work. They end up selecting shots that have emotional or sentimental value to them, but do not work in a portfolio. Try to get professional assistance if you can afford it or if you have a relationship with an art director, designer, editor or buyer, ask them to evaluate your portfolio before you submit it for review.

SECRET #11: PRICING YOUR WORK (PART 1)

When you wish to sell or publish your work, you'll have to decide how much to charge for it. To get what you are worth, consider these propositions.

You are not selling square inches of paper for the cost of printing them. For some reason, the first element that seems to enter a photographer's mind when making a pricing decision is the size of the print. This "brick wall" has cost many photographers money. The most important thing to keep in mind is the value of your work. You build this value by evaluating ALL the factors that go into making a salable image.

So what are you selling? How about your creativity and unique ability to capture something that others do not see? Anyone can buy a camera, but can they capture the image exactly the way you do? How about the time you have invested in training for the moment when you captured the image? That time needs to be taken into consideration. Your mechanic, doctor, accountant, and lawyer all get paid for the time they spend doing the work. Shouldn't you be paid too? You also have to consider the level of your present technical ability. The casual amateur may not be able to get the most out of the same equipment as an experienced professional. And speaking of equipment, you must also take into consideration the value of your gear. So, as you are deciding how to price your work, make sure you take into account and charge for your logistical skills, experience, time and your ability to translate your client's desires into a visual statement.

Be sure to consider the entire package when you prepare a price quote. It may be tempting when you are first starting out to give people "deals," but those prices will come back to haunt you in the long run and will also bring down prices in the industry. So don't do it.

SECRET #12: PRICING YOUR WORK (PART 2 - PRINTS)

In order to price something, you must know the manufacturing cost. Here are some key things to keep in mind:

Pricing Economics

A) Overhead
B) Profit margin
C) Your market

Calculating your overhead requires that you consider all the costs that are associated with being a professional photographer. This includes:

A) Equipment depreciation
B) Insurance

C) Rent
D) Licenses
E) Legal fees
F) Accounting fees
G) Payroll fees
H) Salaries
U) Taxes
J) Utilities
K) Production
L) Repairs
M) Printing
N) Postage
O) Office supplies
P) Subscriptions
Q) Professional dues
R) Advertising/marketing
S) Transportation/shipping
T) Travel

Calculating profit is easier. You consider your cost of doing business by allowing for a percentage of your overhead to be applied to the cost of each job. From there, mark up your price to include a standard profit margin. This can be based on any number you want but a good starting point is to double the cost of your product (100 percent profit margin).

Now, you also need to adjust this figure based on the *market type you are serving*. Is the image being used in a small or large market? Will thousands of people see it or just a few? What is the perceived value to the client? How does the client plan to use your image? Who is your competition and what choice does your client have besides you for this type of image? Are there 50 photographers in the mix or only two or three? Consider these factors to calculate your fee.

SECRET #13: PRICING YOUR WORK (PART 3 - NEGOTIATION)

When you sell or license an image, it is likely that you will have to negotiate the price with a savvy photo buyer. Knowing how to negotiate can save you time, money, and help you close profitable deals. Remember that negotiating is just problem solving. Both

parties have something they need to accomplish and the negotiation makes it happen. You must not take ANY of the issues that arise during a negotiation personally. The buyer is supposed to try to get the best deal that he or she can. That's their job. Your job is the same.

The essential steps in the negotiating process are: establish rapport, gather information, do research, ask questions, and let the buyer do most of the talking. In any negotiation, the person who listens most is likely to gain more. In any negotiation, it's always very important that you do more listening than talking. Otherwise, you will miss important clues, both physical and verbal, that will help you resolve the deal.

Before quoting a price, you must try to educate the client and build the value of the image you are selling. Make sure that the client understands the effort, time, and expense you invested to make this image. Those factors translate directly into the value of what you have for sale.

Try to encourage the client to place an opening bid. If the buyer is the first one to name a price, I believe you will be rewarded with a higher fee. A good way to open the negotiation process is to ask a question like, "What's the most you would be willing to pay for my image?" If you are forced to begin the negotiation process by offering a figure, an alternative is to begin with a number that is twice your standard price plus 10 percent. Once this figure is given, you can work down from there.

But remember that if you give a number first, you run the risk of quoting a price that is much lower than the buyer was willing to pay, and you'll never know what figure they were willing to pay. So, let your clients do the talking. Then, you should listen, take notes, and preferably wait for them to tell you what they can afford.

If the client has pricing objections, be sure to return to the rapport building and value enhancement stages outlined above. Usually, a price objection really means that there is another piece of information you have not uncovered. It is likely that there is

something else you have not offered that the client really wants or needs. This is why it's crucial to listen more than you talk and ask plenty of questions to uncover hidden needs.

Once you have taken all the necessary steps, be sure to ask for the order. A surprising number of photographic sales don't happen simply because the seller has forgotten to ask for the sale.

(NOTE: Negotiating with magazines is not possible unless you are a famous photographer with images that are in great demand. When you approach magazines, understand that you will only get paid their standard rates.)

SECRET #14: WHAT IS SALABLE?

If you want to sell or publish your photographs in magazines, books, or newspapers, as well as be contacted by advertising agencies and stock agencies, you need to offer the right images. The right images always feature a "heart beat," meaning that they have people or animals in them. If you're targeting magazines, newspapers and other consumer publications, photographs featuring people outsell images that don't by a margin of seven to one.

So, always try to photograph people in a variety of situations. Shoot people at the beach, at work, driving, walking, hiking, at ball games, and at concerts. All kinds of people make good subjects. Look for couples, singles, older, younger, families and different ethnic groups. Always carry model releases with you to increase your chances of selling these images.

Think of all the places where you see great photography. Now keep in mind that someone had to make, sell, and buy those photos. How many feature people? Simply flip through any popular magazine and the answer will immediately be apparent: photographs of people of all ages and in all kinds of settings sell.

Portraits, weddings, senior high school photos, event photos, and school pictures are all additional opportunities to sell photos.

Along with photos of people, you can also do well selling cute animal pictures. Since animals, like humans, have a heartbeat, there is a tendency for people to identify strongly with animals.

So the next time you go to the national park or the beach or to the mountains, go ahead and make your favorite landscape shot minus people. Then ask your friend, brother, sister, mother, or wife to walk INTO your shot. Now you have a salable image.

SECRET #15: PACKAGING AND BUNDLING

Whether you sell prints, shoot for web sites, license to advertising agencies or publish in newspapers, books and magazines, you can benefit from repackaging, bundling, or repurposing your images.

Don't worry if your competition is not packaging or bundling. Do something wildly different to change the outcome of any unsuccessful marketing campaigns you have tried.

One way to do this is to combine several images together as a bundle. Some of the successful techniques include shooting with another photographer and co-publishing. Here's another option: You can reduce or enlarge the size of your prints and adjust prices accordingly. Look at and think about your strategy from a different perspective. Take a problem or a situation that is not going the way you want it to go and turn it inside-out. How would you change your photograph if it were going to be inserted as a premium into boxes of cereal or appear inside an automobile glove box?

You can also try to sell pictures internationally or sell the foreign rights. Pitch your photos for other applications such as a calendar, a board game, and greeting cards or for the art background for a movie or a TV series.

Change your thinking. Shake it up. Ask yourself not only why people are buying your photos, but also why they are not. What could you change to create a different outcome or fresh alternative? Can you try a different pace? Change the schedule?

Sample Photo In Frame

Have you thought about eliminating elements to reduce the cost (without reducing quality), such as framing, double mats or large prints? Rethink how you package your product, and you may discover new markets.

SECRET #16: GIVE GREAT CUSTOMER SERVICE

Solving your customers' problems will help you sell and publish more photographs.

Treat everyone you deal with as if they were your customer. Why? Your customers pay your salary. They make your job possible. So who are your customers? Everyone you come in contact with: your vendors, family, clients and many more. If you adopt the attitude that everyone is your customer, you improve the chance that they will influence future sales.

Once you have customers you are also bound to have customer service issues. How you deal with those issues will have a great impact on how successful you will be at selling or publishing your photos.

When your customer has a problem, you must find out what should have happened, what didn't happen and what needs to happen. Giving good customer service is about attitude. When a problem occurs, treat it as a challenge or an opportunity not as a problem. Ask questions and listen. As with selling, follow the rule of listening more than you talk. Don't interrupt, get defensive or allow your personal feelings to become involved. Show empathy, apologize and ask how you can fix the problem.

If you focus more of your energy on listening, you will often discover the real problem or real need. Once you provide a solution, don't forget to invite them back and let them know that you value their business.

Have a plan to solve common customer problems and treat each customer service issue as a potential opportunity for a new sale – because it is.

SECRET #17: THANK YOU NOTES

Thank you notes can be powerful tools. I try to send a personally written thank you note to every customer within 24 hours of doing business. If I get hired to photograph a wedding, I send a thank you note as part of my follow up communication. I also follow up with a note after the bride and groom pick up their photos.

On the publishing side, I send thank you notes to editors who buy and publish my work. They are often surprised to receive my note since most photographers take them for granted. I let them know that I appreciate their confidence in my work.

Here are a few other occasions when a thank-you note is appreciated.

· When a client refers you to a friend.
· When a newspaper reporter writes a story about your business.
· If a local business agrees to partner with you in a co-marketing promotion.

Thank-you notes should be hand-written on nice stationery (featuring one of your photos) and should be mailed first class mail in a hand-addressed envelope. Alternatively, you can send printed thank-you cards that you can find at any of the major stationary stores.

Get into the habit of sending thank-you notes, and it will help mold your business identity. It takes time, but it's absolutely worth it. Thank-you notes are a simple, inexpensive, and effective marketing tool.

SECRET #18: LEAVE BEHINDS

When you speak in front of an audience, show your images at a nursing home, meet with editors to show your portfolio or talk to anyone about your photography, be sure to have a leave-behind. Business cards are also a must, but you need more than a business card to leave a lasting impression on prospects, clients or potential business partners.

I use bookmarks very successfully. I put a striking image on one side of the bookmark and a calendar on the other. I always include my website and my full contact information. Another great leave-behind idea is a calendar. Calendars allow you to leave prospects with a mini portfolio that includes 12 images and corresponding calendar information with contact information on every page.

Scott Bourne
Photography
www.wildlifeshooter.com

Sample Bookmark – Great Leave Behind

Newsletters are a powerful leave-behind. Include recent news about your career along with highlights of work for recent clients, awards, new hires, and new equipment.

If you have published a photography book or magazine article, leave one behind. It's an inexpensive form of promotion and always impresses clients.

SECRET #19: BE EVERYWHERE

There's no substitute for promotion. If you want to be successful selling and publishing your images, your market needs to see and be aware of you all the time. And while you are at it, you can contribute to your community.

Here are some suggestions:

1) Join local service and business organizations.
2) Offer to do training programs at local schools and camera clubs.
3) Volunteer to teach workshops and seminars.
4) Volunteer to help with charities (try donating one of your photographs as a raffle item).

5) Present slide shows at nursing homes.
6) Offer to volunteer at a school's art class.
7) Mentor someone with an interest in photography.
8) Sponsor a community photo contest.
9) Speak at national conferences.
10) Offer to participate in radio and television interviews.
11) Make sure that your local newspaper knows you are available for interviews about photographic topics.
12) Write a column for local and national magazines and newspapers.
13) Turn your photography expertise into multimedia assets. Make instructional audio and videotapes. Put streaming media online so that people can access it on your website.

SECRET #20: BE A PUBLICITY HOUND

Public relations is the best form of inexpensive promotion. For a very small investment, you can deliver press materials that will attract thousands of dollars of media attention.

The Press Kit

The foundation of a basic PR plan is a press kit. This collection of materials placed inside an attractive two-pocket folder will help you sell your message to media outlets. For best results, create print and electronic versions of your press kit.

Format

Many press kits are delivered the old-fashioned way on paper. You can also provide your media kit on a CD-ROM or post it on your website for the media to download.

For the print version, a two-pocket folder with a slot for your business card makes an excellent presentation. You can buy nice folders at most office supply stores. In some cases, you may want to have a custom folder printed. If you have a bigger budget, you may want to invest in professionally designed identity materials that include matching folders, stationery, business cards, and leave-behinds or brochures.

Press Kit Contents

The most important piece of information in your press kit is your business card, so reporters and editors can easily contact you. Your business card should be placed in the slot in the folder so that it is easily noticed when you open the folder. Next, you will want to include your most recent press release. This can be information on new equipment, awards, services, locations, contracts, or employees. If you have distributed previous releases put the five most recent releases in the folder with the most recent on top. If you have written dozens of releases, select the most notable releases.

Behind the press releases, include copies of newspaper or magazine articles that have been published about you. After the article reprints, include a one-page fact sheet, short biography, and an artist's statement if you are selling art prints. If you have more than one photographer working in your company, include bios for each one.

Put a 5"x7" color photo of yourself (as well as other key players in your organization) in the kit, along with either tear sheets showing your published work or a catalog page providing thumbnails of your five best images. Next comes another very important piece of information: the company background document. This is a written history of your company's major milestones, accomplishments and mission. It should include a full description of your services, record of successes, clients and anything else that would impress a reporter or editor.

You should also include a written feature story about you or your business. Reporters are very busy and occasionally they will publish this story verbatim.

You can also include the most recent edition of your company brochure or newsletter

Sending A Press Kit

Before you distribute your press kit, you need to know who to send it to. Many local chambers of commerce offer a media list that you

can request at no charge. Once you have a copy, identify your best prospects. Make a database on your computer and keep track of these contacts.

If you want to mail a press kit, be sure to include a short letter of introduction. In this one-page document you want to explain why the media and its audience should be interested in your news. This is also a perfect place to suggest story angles or to highlight the strongest selling points about your work and your company.

Before you mail your press kit, always call to make sure you have spelled the name and address of the recipient correctly. Neatly package the material and send it by overnight carrier or USPS Priority Mail. Time the delivery of your press kit with a newsworthy event or announcement.

See my sample news release in the appendix.

SECRET #21: PUBLICITY (PART 2)

The "Available for Interview" Kit - Improve your visibility by becoming a news source and expert commentator.

As a photographer, you possess specialized knowledge that makes you a valuable resource for journalists. Being quoted in a news story is an excellent way to gain added visibility in your market. Once you have developed your press kit, you may want to create an "available for interview kit" as well. It positions you to be an expert and commentator for news and feature stories.

This kit contains some of the elements found in your press kit. Use the same folder and business card as you do in the press kit. Then add your biography, company background brochure, personal photograph and copies of previous articles where you've been quoted. You may also want to include transcripts of radio or television news stories that quoted you.

Include copies of speeches or presentations, particularly if they highlight your specialized knowledge. Also include statistical data such as charts and lists that describe the state of the photo industry.

Finally, prepare a list of topics that you are qualified to discuss. If you have a videotape from a previous interview, mention its availability in the list of expert topics but do not send the tape unless it is requested. Whether you are writing a press release or building a media kit, public relations is the most cost-effective aspect of a complete marketing plan.

SECRET #22: PUBLICITY (PART 3)

Here are additional ideas to round out a complete publicity campaign. Pick the options that you feel will work best for you.

a) Offer free photos or free photographic services to local media as a contest premium. For example, if your radio station sponsors a summer beach party, offer to give free photo sessions in your studio incorporating a beach theme.

b) Create both audio and video versions of your press materials. This increases the likelihood that major broadcast media will run your story.

c) Conduct photo contests at local schools and give prints or photo lessons to the winners.

d) Concentrate your public relations efforts locally. Then expand into your county, state, national, and international markets.

SECRET #23: YOUR RESUME

Publishing and selling your images is very similar to searching for a job. So a custom "artist's resume" will be a powerful weapon in your marketing arsenal.

This resume should be a summary of all your photographic achievements. It should list the major publications that published your work, as well as exhibitions, or gallery showings you have had. List your photographic education along with any awards you have won.

Update your resume when you have any significant career changes.

Résumés should be printed on fine paper. Never make your resume more than two pages long, and if possible, consolidate it to one page. If you have extensive photographic experience, highlight only your major accomplishments and briefly list the rest.

You may want to create more than one resume, depending on the markets you wish to serve. For instance, if you want to attract brides looking for a wedding photographer, highlight the portrait work and your related education. If you also want to show your work in galleries, create a resume that focuses on your fine art success.

See my sample resume in the Appendix.

SECRET #24: SET GOALS

You can't know whether or not you've been successful in business unless you have established goals. Goals are strong success motivators. You need to set realistic goals that you both believe in and want to achieve. Pick positive goals that do not conflict with your values. Pick attainable goals but make sure that you set the bar high enough so that you stretch to achieve them. Create short, medium, and long-term goals. Write them down and look at them often to make sure that you are on track.

After outlining your goals, develop an action plan. As part of your plan, re-evaluate your goals on a regular basis. Modify them to meet the changing conditions and demands of your business.

SECRET #25: THE RULES OF GOOD SELF-PROMOTION

Photographers need to aggressively promote themselves if they want to get published or hired. Here are some basic rules for good self-promotion.

1) Make sure your contact information appears on *everything* you mail or show to the public.

2) Expect to contact someone at least seven times before they start to pay attention to you. Sending only one postcard just won't be effective.

3) Don't sound needy. Sounding desperate doesn't motivate people to hire you.

4) Work out co-marketing agreements with like-minded vendors and share advertising space with other photographers. Even though you risk losing a job to a competitor, you will have more impact by joining forces with another photographer.

5) Give clients premiums that feature your work and contact information.

6) Obtain permission to include testimonials from satisfied clients. Use them with your printed materials and as part of your sales pitch.

7) Use one dramatic photograph with high impact on your marketing pieces instead of several smaller images.

8) Feature only your best work.

9) Use the media to spread the word about your photography business and yourself.

10) Do steps one through nine over again.

SECRET #26: MAKING A SALES PITCH WITH INTEGRITY

When you get the chance to sell your photographs or to show them to a publisher, you are, in effect, going on a job interview. It is up to you to effectively pitch your work and yourself to your clients.

Make sure you are dressed appropriately. Use good hygiene and be polite. Presentation matters. Make sure that you discuss your qualifications for the job. And be both a good communicator and a good listener. These are the key skills required to sell your photography.

You also need to pay attention to your body language. Always try to sit at eye level with the person to whom you are pitching. Don't tower over them or let them do the same to you. Call the client by

name and maintain eye contact. Always take a friendly approach and never get defensive.

Keep a positive tone and do not get defensive when your prospect raises objections. Use the FEEL, FELT and FOUND approach to dealing with objections.

"Mr. Smith I understand how you feel. The price I am asking for sounds high. I felt that way too until I found out what it would cost me to actually make the images you want to buy."

Empathy goes a long way toward getting the buyer on your side. Try to make your pitch with the buyer's needs in mind. If you have a true meeting of the minds and everyone wins, you will have not only a chance to make a sale, but to gain a client.

SECRET #27: GOOD PHONE MANNERS

Sometimes it's the little things that help you make a sale. Here are some secrets for using the phone to your advantage.

a) Pay for a business telephone line, and you will receive a free listing in the local yellow pages. By having a dedicated business line, you will always be able to answer your phone professionally, even if you have a home office.

b) Answer the phone promptly and with a smile. Be polite, attentive, and give the caller your full attention. Disable call waiting! It's rude to tell a customer you have to place them on hold in order to answer another call. You're sending a message that another call might be more important.

c) Use voice mail to its full extent. Leave a voice mail message that tells your callers exactly what you need from them, and don't be afraid to do a little selling at the same time.

d) When the caller asks for someone at your company who is not in, say, "I'm sorry, Mr. Smith is not available, may I take a message for him?" Don't tell the caller that Mr. Smith is in the restroom, at lunch, or at school. This is not appropriate.

e) Always be sure to let the caller to finish his question before answering. Never interrupt the caller.

f) Always return messages promptly.

g) Consider having a toll-free number. It removes any hesitancy that customers may feel about calling.

h) Invest in a high quality phone that makes it easy for you and your customers to hear each other.

i) Avoid cell phone conversations if you can since their quality is often poor compared to landlines.

j) Do not take phone calls when you are meeting with a customer face-to-face. Let voice mail answer your calls and give your full attention to your current customer.

SECRET #28: USING TESTIMONIALS

Testimonials are probably the single best form of promotion available to photographers. If you publish your images in a calendar, on greeting cards or posters and the items are selling well, ask the publishers to mention this in writing. Include a copy of that letter with your next submission, and you'll receive more careful consideration.

If you wrote a travel piece for your local paper and illustrated it with photos, ask the editor if the story was well received. If so, ask for a written testimonial.

And if you offer studio photography services, don't forget to ask your clients, whether they are portrait, wedding, catalog, food or product buyers, for a written reference.

I make it part of my standard marketing practice to ask for a one paragraph testimonial on letterhead from clients.

It's important that your clients write the testimonials on their letterhead to provide a professional statement.

I use testimonials in publicity kits, sales kits, framed on the walls of my studio, when I am applying for loans or leases, and when I am showing my portfolio to prospects. Any time you pitch your photos, you should include a testimonial from a satisfied customer to help bring the prospect to a buying decision.

Testimonials reassure potential clients that they are making a wise buying decision, especially when they are dealing with a photographer they don't know.

SECRET #29: MONITOR YOUR COMPETITION

Photography is one of the most competitive occupations in America. Think about it. Do you know ANYONE who doesn't own a camera? Everyone "thinks" they can take a good picture. Some people do. But frequently, people with horrid photographs ask me if I think they should quit their day jobs to become professional photographers.

Obviously, it's the serious, professional photographers among us that we need to view as competitors. And I believe in working with my competition, not against them. But I also believe in keeping an eye on what they do.

What can you learn from studying your competition? You learn about new marketing opportunities, compare product offerings and pricing, and sometimes even find new sales.

Pay particular attention to other successful photographers who work in your target market. If you are a wedding photographer, look at the studios in your town that have the biggest ads and the best reputations. What is it that they are doing that you could do too? Study them and borrow their successful ideas. You never have to apologize for adopting someone else's successful marketing technique.

Keep a file of your competitors' brochures, advertisements, press clippings, and other marketing literature and review it periodically. Meet with your competition and ask what is working well for them. If they are seasoned pros, they will see the benefit of helping their competition succeed. Inexperienced pros tend to bring prices down.

If you want to get the most out of studying your competition, make a spreadsheet and keep track of the following:

a) Number of competitors.
b) Sales capacity.
c) Markets and market share
d) Marketing programs.
e) Advertising budgets.

Remember that you can learn from your competitors' successes and failures.

SECRET #30: GET LEGAL

Part of being a professional is staying within the law. This includes applying for required business licenses. It will show prospects that you are a serious and legitimate businessperson. By displaying your business license, you demonstrate that you conduct business professionally, ethically and within the law. Each municipality has their own rules. In some states, photographers are required to have a state business license. And in some cases, city governments require business to obtain a business license. Collectively, these licenses cost only three or four dollars a month. It takes only a few minutes to fill out the forms.

You should also be bonded and insured. This will further confirm in your clients' minds that you are a legitimate businessperson. It will also protect you in the event of problems.

Once you have the required licenses and permits, follow the rules for displaying them and renewing them when they expire.

If you want to do business with any government entity, you must be licensed. Governments hire photographers too, so don't miss out on that profitable piece of business because you failed to apply for a business license.

SECRET #31: GETTING REPEAT BUSINESS

It's always harder to get a new customer than it is to keep an old

one. Once you have a relationship with a client, and someone has purchased your work, that contact is golden. You have now won the right to call that person and pitch new ideas to them. You are a trusted source since they have had a successful experience with you.

Always be reasonable with your clients. When you negotiate price and service, remember that you want to have this opportunity again.

Contact your past clients on a regular basis and inquire about their photographic needs. Remind them of the successful work you did and of the features and benefits of your previous job that they liked the most.

Try to anticipate your client's needs. If you can help your clients become more successful, they will reciprocate and do more business with you.

Remember that it's safer for the client to work with someone who they know and is proven rather than someone they don't.

SECRET #32: YELLOW PAGE ADS

There is one simple way to get your local market to know that you are a professional photographer: run an ad in the local Yellow Pages. This is particularly important for emerging professionals.

The advantage of the Yellow Pages is that potential customers who are actively seeking the products you sell, will be informed about your services.

Remember to write your ad from the customer's point of view. Reach out to your prospects on an emotional rather than a technical level. In other words, your customers are more interested in your ability to protect their memories than they are in the quality of your equipment. Most of your customers are likely women, so try to create messages that appeal to this audience.

Do be aware of the fact that Yellow Page ads tend to encourage price shoppers. Your strategy should be to convince Yellow Page customers to come to your office. Don't try to sell them a photo or

photo session over the phone. Instead, try to get them to come in and see your portfolio.

When you write your ad, be sure your copy demonstrates:

1) Something that differentiates you from your competitors
2) An indication of price
3) Quality
4) Experience and credibility
5) Your trust and honesty
6) Location of office and office hours
7) Contact information
8) A warm tag line that indicates you are more than a technician

Also, make sure that your ad has a strong headline and a clear call to action. Remember you are trying to sell an appointment, not a photograph. Giving prospects a compelling reason to contact you along with simple directions will yield the best results.

Sample Yellow Page Ad

SECRET #33: MISCELLANEOUS TIPS

In writing this book, I took some time to talk with friends who are professional photographers. I asked them for their best secrets and tips for aspiring photographers. Here is a list of the best secrets they shared:

a) Concentrate on selling the images you have. Don't worry about what the editors SAY they want, show them what you have and try to make a deal. As long as your work fits the type of work they usually buy, you may be able to make a sale.

b) Don't think that great work is enough. You can be the best photographer in the world, but no one but you and your family will know it if you don't market and sell your work.

c) Focus on a specialty. You'll have a better chance of selling your work by having a niche.

d) Stay with it. Don't forget that this is a numbers game. You have a better chance of selling your work if you show it to more people. Also, don't forget that you have to have multiple contacts with the same people to generate awareness of your work. One call does not do it.

e) Take the old photographic business paradigms and flip them. If you can think of a new way to do an old thing, you will be unique in your market.

f) Set goals and keep track of them or you are just fooling yourself.

g) Don't pick photography as a career if you want fame and fortune. There is a saying that, "photographers get paid in sunshine and smiles but rarely with buckets full of money."

h) If you can spend as much time developing your marketing skills as your photography skills, you can make a living as a photographer.

i) If you photograph what you enjoy and are passionate about it, you will be more likely to sell and publish your work.

j) Take the hour before everyone arrives at work and set that time aside to promote yourself to markets in different time zones. Work harder than your competitors to market yourself. Regardless of who is the better photographer, you will have more success.

k) Be a stickler for quality and great customer service.

l) If you're not excited about your work, how can you expect editors to get excited about it? Shoot what interests you.

SECTION TWO – PUBLISHING SECRETS

SECRET #34: EFFECTIVE QUERY LETTERS

The first step to publishing a story or photograph is the query letter. Some editors want to read an entire article before they will agree to publish it, especially if they are dealing with a new writer or photographer. But more often than not, editors want to see a query letter.

The first paragraph of the query letter should contain information that immediately hooks the editor and explains why readers will be interested in your submission. The letter should outline your credentials as a writer and photographer. It should also detail the photos that you will provide to illustrate the story. Lastly, you should discuss exactly how your idea is a perfect fit for the target publication.

Your query letter needs to be brief. Get right to the point immediately and be specific. If you can't immediately interest the editor, you won't get hired.

These are the questions the editors will ask as they read your proposal: "What does this information mean to my readers?" "Why will they care about this?"

Unless you can help the editor quickly see the answers to those questions, you won't be able to close the sale.

See my sample query letter in the Appendix.

SECRET #35: E-BOOKS

If you are having trouble getting your photos published by a traditional publisher, consider producing an e-book. An e-book is a digital file that readers can purchase and then download or receive on CD-ROM. You can read e-books on a special reader, computers or print them.

E-books don't have to be printed on sophisticated presses, bound, inventoried, or shipped. E-books are never returned for a refund. You can sell e-books on your website, at regular bookstores, on Ebay,

on Internet photography forums, or on Amazon.com. If you want to sell in bookstores or on commercial websites like Amazon, you must agree to their terms and rules.

Photography e-books are most popular when they are written with a how-to, travel, or adventure approach. For example, it will be easier to sell an e-book that features pictures of Yellowstone National Park if it is written as a travelogue rather than an attractive Yellowstone picture book.

If you have a particular photographic area of expertise and can write about it, you can write an e-book and sell it. Of course, your pictures will be used to illustrate the book so you will be selling your pictures at the same time.

You can build the e-book in any number of software programs such as Quark, PageMaker, Adobe InDesign, Microsoft Word or Adobe PageMaker. Then you use additional software to convert those files into an e-book.

Adobe Systems makes a product called Acrobat that will help you to make E-books. Every computer sold today comes with an Adobe reader. Adobe's reader software is also available free of charge from their website. (www.adobe.com)

If you'd like to know more about how to make an e-book using Adobe's software, visit: (www.adobe.com/products/acrobat/main. html). For more information on adding a shopping cart to your website, visit: (www.paypal.com/cgi-bin/webscr?cmd=p/xcl/rec/sc-intro-outside).

Once you have created your e-book, you can set up a shopping cart system on your website and sell your e-book online. Depending on the size of the e-book, you could make your e-book available to download from your website. If the e-book files are large, you may want to burn it onto a CD-ROM and ship it to customers for an additional fee.

SECRET #36: MARKETS WITH LESS COMPETITION (PART 1)

LOCAL NEWSPAPERS

Search for publishing markets that have less competition. The less competitive publications may not have the curb appeal that major national magazines do, but they don't receive as many submissions. Access to less competitive markets is crucial for emerging photographers.

While you're at it, don't overlook the value of local weekly newspapers. Small-town weeklies traditionally cannot afford to hire a full-time staff photojournalist. This gives freelancers a tremendous opportunity to break into print.

If you have a child on the local high school football team, consider getting permission from the coach to photograph the game from the sidelines. Then, contact the local sports editor at the weekly and let him know you will have images the next day. This means that you will have to shoot digitally, although if you shoot black and white and process your own film, you could have contact sheets ready in the same time frame.

Sports assignments are just one example of hundreds of events in your local community that offer photo opportunities. In just one week in my town of 3,500 people, there was an art festival, the opening of a new city park, three new business openings, the swearing in of a new fire chief , 54 Little League baseball games, a soccer tournament, and a farmers' market. All of these events, combined with breaking news, such as car accidents, fires and weather events, provide opportunities for you to publish your pictures. In most cases, you will even be paid a small sum. My local paper pays $50 per photo. You won't get rich, but it will help you pay for film, disks, or more gear, and you'll receive clips that you can use in your portfolio.

SECRET #37: MARKETS WITH LESS COMPETITION (PART 2)

OTHER SMALL MARKET OPPORTUNITIES

I've discovered many small market opportunities in shooting for trade publications and small presses.

When it comes to trade magazines, I am not talking about magazines that you find at your local bookstore or newsstand. These are magazines that you've probably never seen unless you're a member of an association or deeply involved in a particular industry. These publications often pay better than some consumer magazines. They can be good, consistent clients that provide steady work.

Small presses and independently owned publishing companies are also good customers for emerging photographers. The Publishers Marketing Association (www.pma-online.org) is a great source for listings of small book publishers.

You won't become a household name shooting for these markets, but you may very well get paid like one.

SECRET #38: EDITORIAL SUBMISSIONS

When you submit images for publication or for purchase, make sure to present them professionally. Be sure to include a self-addressed, stamped, return envelope (SASE) with every submission if you want your images returned. Never send original photos since sometimes even a SASE isn't returned. Also, be careful not to use staples, excessive packaging, or too much tape.

Be sure to include a cover letter that includes all of your contact information. If you are submitting digital files made with Photoshop, go to FILE > INFO and type in your name and phone number.

Also place your name and phone number on every print or slide. Photo buyers frequently have lots of images lying around their offices from hundreds of photographers at any one time. If your images get separated from your package, you don't want to miss

a sale because the buyer doesn't know who owns the photo. Type or neatly print all requested information. Always address your submission to an actual person instead of the title of the person you are pitching.

SECRET #39: MAKING A SUCCESSFUL SUBMISSION

The submission is the first real impression that an editor will have of you so it is important to make a professional presentation. First, try to obtain and follow all the publication's submission guidelines. Next, pay attention to detail. Don't be sloppy. Using duct tape may sound good when you want to affix that troublesome bumper to your '57 Chevy, but its overkill when submitting photos. Use new, clean and appropriate packaging for the submission. Put your photos between two clean pieces of cardboard with rubber bands around them.

I believe that sending things overnight has more impact unless guidelines prohibit it. Never send anything to arrive on a Monday or a Friday. This will keep your submission from falling into a big pile that frequently gets ignored. On Mondays, editors are catching up with all the mail that came in over the weekend. On Fridays, they are usually trying to meet a deadline and want to leave for the weekend.

Therefore, mail your package so it arrives during the middle of the week, unless the editor has contacted you and requested something different.

Try to think like the editor and understand what a typical day is really like. One way to do this is by volunteering as an intern. You will see that the pace is very hectic.

Print editors have to go to meetings called "budget meetings." These meetings have nothing to do with money. They have to do with space. For instance, in a newspaper, the concern is always about how many column inches need to be filled that day and what stories need or have photos.

Editors make assignments and filling that news hole is the priority. So learn to think like the editor if you want to sell your photos to a newspaper.

SECRET #40: WRITE TO SHOOT

There's no denying that photographers who can write, or who have a partner who can write, will publish their photos before someone who cannot write. If you want to have a better chance to publish your photos, pitch a story idea.

Not only will you have a better chance of getting published, the good news is that you'll also get paid more because you will get paid for writing the story as well as photographing the illustrations. Also, writers generally get paid more for their work than photographers.

Almost anyone can learn to write. The best way to become a good writer is to be a good reader. Look at the story style of the publications you want to target. Then match the writing style and tone.

Carefully analyze the magazines that interest you the most. Study the types of features they publish and learn their submission policies and style guidelines.

If the thought of trying to write is not something you want to tackle, then you need to collaborate with a writer. This is just as valuable as writing the copy yourself.

All that magazine editors care about is whether the story matches their editorial calendar, their editorial guidelines, and their readers' interests. If you can deliver on those three issues, either on your own or with some help, you can get published and paid.

Here are several resources about writing:

On Writing Well by William Zinsser is a classic book about writing.

Writer's Digest magazine is full of specific how-to information targeted at fiction and non-fiction writers.

SECRET #41: GREETING CARDS & CALENDARS

Greeting card companies and calendar companies are large consumers of photography. Unfortunately for emerging photographers, they buy mostly stock photography. To break into these markets, you need to be persistent.

You'll need to treat greeting card and calendar companies the same way you would magazines. Look at their product line. Visit company websites or write and ask for submission guidelines. You must study these markets carefully. Since greeting cards have to convey their messages in a limited amount of space, your photos must perfectly match the message.

One nuance of shooting for greeting cards is to understand the "voice" that cards are written with. Most cards are written from a very personal "me to you" perspective. Make sure your photos reflect that same feeling. You can do this by submitting photos that have emotional impact.

When it comes to submitting images to card companies, don't start with Hallmark or American Greetings. Approach smaller local or regional card companies.

Calendar publishers are a bit more receptive to photo submissions. They tend to request thematic submissions. For example, calendar companies look for 12 cat pictures, 12 train pictures, and 12 car pictures. The more original you can make the theme, the more likely you are to see your work accepted for publication.

To break in to the calendar business, consider shooting for charity calendars so you can build a portfolio. Your local church, school, or community service organization may publish a calendar. Volunteer to make photos for these calendars in return for a photo credit. Then you will have published samples to include with future commercial submissions. It also shows calendar photo buyers that you have published and are publishable.

SECRET #42: POSTERS

Poster companies publish tens of thousands of images each year. Sports figures, celebrities, cars, and pretty girls are at the top of the list of categories for posters. Other popular categories include wildlife, scenic landscapes, and street scenes.

If you want to sell your photos to poster companies, find one that publishes images that are similar to those you shoot. Ask poster companies for their submission guidelines and then send them only your best work. Try to find images that mirror those you have seen in other published posters. If you want to look at examples, visit your local frame shop, bookstores, and gift shops that sell posters.

While many photographers dream of seeing their pictures turned into mass-market posters, shooting photos for local and regional poster clients offers greater opportunity.

One often-ignored market for posters is the music industry. Many emerging musical groups make posters to announce their upcoming gigs. If you can link up with these groups, you can offer your services as a photographer and build a portfolio. Once you are established, you can use copies of posters you made for these musical groups to market to other groups.

Other potential customers for poster photographs are garden shops, restaurants, nightclub acts, community theatre groups, and schools.

SECRET #43: STOCK PHOTOGRAPHY

Some of the first photo sales I made as a new photographer were to stock agencies. Today, most of the stock agencies are saturated with images. But if you know what they are looking for, you can still make sales.

The biggest secret to successfully working with stock agencies is to specialize. If you shoot nothing but underwater, train, or motor sports photographs, it will be easier to sell stock photos than if you were a generalist.

You also need to become accustomed to photographing people. The majority of stock photographs sold in the United States contain pictures of people. Since these images are usually used for advertising purposes, you also need to become familiar with and use model releases. The majority of my most successful stock images feature professional models, so it's easy to get releases signed when I do the photo shoot.

Another secret to selling stock shots is to know the types of photographs the agencies look for. Do this by looking through magazines to see the types of images that sell.

Now that you see the types of images that stock agencies acquire, think "concept." What concept does your image portray? If you can't quickly identify the concept, then your image is probably not appropriate for stock sale.

Here are some hot-selling stock concepts.

Professional Sports
Extreme Sports
Medical Surgery and Emergency
Contemporary Families
Multicultural Families
Holidays
Babies
Business Groups
Everyday Faces
Family Vacations
Water
Fitness
Patriotism
Diverse Workforce
Faces
Friendship
Children at Play
Americana
Golf
Seasons

Another way to figure out what stock agencies need is by asking for a want list. These are detailed lists of images that buyers know they will need for upcoming projects. These lists may be hard to obtain, and not all buyers maintain them. If you are lucky enough to get a want list, work to fulfill those needs first.

Want lists are valuable because they help emerging photographers learn what the buyers are willing to pay for. This is a valuable lesson because what buyers want and what photographers want to shoot are often different.

SECRET #44: SELF – PUBLISHING

One way to publish your photos is to publish them yourself. You can use any number of vehicles including postcards, greeting cards, calendars, and books. Self publishing has become relatively inexpensive and easy with the new technological advances in electronic prepress and print-on-demand printing. Depending on the kind of photography you do – color or black and white – you may be able to profitably publish your own work. Black and white images can be easily reproduced using new printing technology called print-on-demand (POD). This allows you to run short press runs of a few books at a time. Color photographs do not reproduce well using POD technology.

If people are already buying your images, you can probably be successful at self-publishing. Find an easy way to break in to self-publishing and get public feedback on your images and your business practices. Here are more ideas:

Self Publishing Tips

1) Join the Publishers Marketing Association. (www.pma-online. com.) They have resources for self publishers that help you learn how to get bookstore distribution, save money on printing costs, get publicity and much more.

2) Buy the *Self Publishing Manual* by Dan Poynter (www. parapublishing.com.) It will give you a complete road map for writing, publishing, and marketing your own book. Even if you

aren't publishing a book, you can still learn something from Poynter's book. Many of his suggestions apply to calendars, magazines and other non-book items that are printed and distributed through bookstores. His website also lists numerous resources for self-publishers.

3) Test the market's appetite for your self-published materials. Make one-off copies of your cards, calendars, and books and take them around to local stores. See if they are interested in selling your products. Of course, you will be more successful if you have compelling work. What makes for compelling work? The answer is anything and everything from something that is attractive to something that has a strong local tie. For example, if you live near the Grand Canyon, you might be successful selling Grand Canyon calendars, since tourists are good prospects.

4) Equity publishing is another way to break into publishing. In the equity publishing model, you team up with an established publisher and participate in the printing costs in exchange for a larger portion of the royalties. Equity publishers do all the same things that traditional publishers do, but they include the author as an equity partner who shares the expense of publishing.

The hardest part of self-publishing is distribution. Distributors take a big chunk of the income and have an unusual amount of control over what is sold. Be sure that you understand distribution methods before you try to self-publish.

SECRET #45: CONVENTIONAL PUBLISHING

If you want to get your images published by a conventional publisher, go to a large bookstore and research all the companies that publish photo books. Check out the books displayed in your local bookstore and library's photography sections.

As you examine the titles, note the publishers in this market and subject areas that are most popular. If you see mostly how-to books displayed, that's a good indication that you should be pitching your images to how-to book publishers. If you see black and white art books, then approach publishers who publish black and white

photography. Learn how to present yourself to the publisher. *Writers Digest* publishes a monthly magazine as well as valuable directories called The *Writers Market* and *The Photographer's Market.* These resources will help you learn how to make submissions.

You can also visit photography trade shows if you want to get a traditional book deal. Publishers traditionally buy booths at all the large photographic trade shows like the Photo District News show Photo East in New York City, the Photo Marketing Association Show in Las Vegas, or the professional trade shows held by American Society of Media Photographers, Professional Photographers of America, and the Wedding and Portrait Photographers International.

Try to meet with publishers at these shows and find out what they want. A personal contact is always more valuable than any other kind.

If you get a standard publishing contract, don't expect a great deal of money. First–time authors in the photography genre get between $1,000 and $5,000 in advance money for their efforts, and the royalty is usually less than 7 percent. Your royalty is a matter of negotiation. The better known you are, the more you'll get paid. If you are just starting, think less about the money and more about the exposure that you will get from traditional publishing.

SECRET #46: NICHE PUBLISHING

One of the best ways to improve chances of selling or publishing your photographs is to develop your own niche.

Just about every professional photographer has a great sunset photo and thinks it should be published somewhere. However, the number of sunset photos that are published is pretty small.

But if you have pictures of something that is unusual, such as a rare duck in flight or a special building with an unusual architectural feature, those pictures are much more likely to publish than something as typical as a sunset.

Developing a niche may be the best way to find a buyer for your photographs. Try to specialize or be as specific as possible. Finding a niche doesn't mean that those are the only pictures you can take. But it does mean that when it comes to selling your photos, this subject is what you are known for and where you concentrate your marketing efforts.

For example, if you make wedding pictures, you should specialize in a particular segment of the wedding industry. You may want to become known for specializing in weddings of African Americans or commitment ceremonies of gay couples. If you are a college football fan, photograph everything related to college football. Then look for editorial and fan-based markets for your images.

This sort of target marketing or niche approach will produce a much higher quality of buyer. It's also easy to sell to a tightly targeted market rather than a broad market.

You'll likely be more successful if you target a specific type of photography to a specific buyer. If you specialize in equestrian photography, you can segment this market in a variety of ways. You can search for information sorted by zip code and contact equestrian associations, riding schools, and breeders. The more specific and targeted you are in your approach, the more likely it is you'll have success over others who are trying to sell a broad range of photos.

SECRET #47: WORKING WITH LOCAL BUSINESS

Every business has a need for photography of some kind. They might need pictures for their website, catalog, advertisements, products or their building. They need pictures of employees for annual reports or business flyers. If you are interested in this type of work, create a portfolio and call on local businesses. Making cold calls is scary for some people. With experience, however, you'll be amazed at how productive it is. It just requires a willingness to introduce yourself to the person who needs your photography.

If you want to sell to businesses, you must turn your photos into products. It's best to start with companies that are familiar. For example if you always go to the same dry cleaner, chances are the

dry cleaner will recognize you. You then need to take 10 seconds and say, "By the way, how would you like me to make some custom calendars you could give to your best customers?"

Developing this kind of relationship with vendors is a very non-threatening and low key approach to sales. Do that with every vendor you use, and you'll start to quickly generate new business.

SECRET #48: CUSTOM PUBLISHING

Think of other products that you could custom publish for local businesses. Perhaps they would like an in-store magazine. Books, calendars, greeting cards, newsletters and flyers are all products that can be custom published.

Establish a working relationship with local designers, typesetters, and printers to obtain referrals. You can generate multiple income streams by creating custom products.

SECRET #49: BEST PLACES TO SUBMIT IMAGES

Your best way to get published in a book or magazine is to pursue publications about familiar topics. If you have a strong interest or passion for a topic, you will likely know more about that subject than your competition. Because you're more knowledgeable, your images will communicate greater authority and expertise.

For example, if you have a passion for old trains, guitars, or barns, it's probable that the photos you shoot of these subjects will be more compelling than those shot by a photographer with no particular affinity for these subjects.

Start publishing with smaller magazines. For instance, if your local conservation group publishes a magazine or newsletter, you won't be competing with a well-known photographer to get published. Smaller publications need images just as much as larger ones. And by starting small, you will develop a reputation and become successful in your local market.

SECRET #50: SUBMITTING TO MAGAZINES

If you want to publish in magazines, the first thing you should do is identify and read the ones that you want to work with to see what kind of photographs they use. For example, if you were to read *Cat Fancy* Magazine you'd notice that they don't publish pictures of dogs. Your best dog shots, as good as they may be, don't have a prayer of publication in *Cat Fancy*. Continuing along this line, you should not submit black and white photos to a magazine that only publishes color pictures. Don't submit verticals to a magazine that only publishes horizontals. Make sure that the images you submit match the theme of the publication.

You can enhance your chances of being accepted by asking for, reading and adhering to the publication's submission guidelines. If you send a self-addressed, stamped envelope, and a request for photo submission guidelines, most magazines will send you a packet full of valuable information. You can also often find submission guidelines on a magazine's website.

If your images are good, and if they tell a story, you'll get a positive response. But if you submit a series of random pictures that don't have an obvious theme or go together, you will likely be rejected. Essentially, magazine photo buyers are looking for photographs as illustrations. To the magazine editor, your images are the illustrations that make a written story more compelling. To the editor, your photo is like supporting material or a prop in a movie.

Choosing photos that are stylistically similar, recognizable as your work, and have a theme will make you a more memorable photographer.

SECRET #51: GET ORGANIZED

How can you sell an image if you can't find it? When the publisher calls and says, "I need your best waterfall shot from Silver Falls State Park now," how will you find it?

If you are scanning your photographs or using a digital camera to capture your images, you have the digital assets you need to create

an electronic database. It's important that you properly organize and file these images now so that you can access them later. You can use computer software to create searchable online catalogs of your images.

To keep things simple, you should store your electronic images in folders that you can easily identify. I personally use a date/location-based system as a starting point.

If I make images at Bosque del Apache in December 2005, I'll place all the digital files in one master file entitled BOSQUE12_2005. Within that master folder, I'll store the raw digital files. I will also maintain two additional folders within the master folder. One will be called KEEPERS and the other BOSQUE12_2005FINISHED.

I keep the un-edited versions of my marketable digital files in my KEEPERS file. The folder marked FINISHED is where I store images that have been corrected in Photoshop and are ready for publication. I add copyright and keyword information to all the images in the FINISHED folder. This makes it easier to retrieve an image using a software search.

I never change the original image numbers created by my digital camera. If I did that, I would run the risk of not being able to find the original file if I need it. So when you name the files in your KEEPERS and FINISHED folders, make sure they have the same file name that they had when they left the camera. It will look something like this. "DCIM73830.jpg." Leave that number alone when you drag files to the other folders and your life will be a great deal easier once you have 100,000 images.

I back up each job at least twice, once on CD-ROM and again on a hard drive and then I label each CD and hard drive. When properly labeled and stored, I can easily retrieve these images.

Here are some popular software programs that make this process easier.

Cataloging Software

• IViewMultimedia Pro
• iPhoto
• Adobe Photoshop Album

Labeling Software Resources

• NSCS Pro / Boyd Norton (303) 674-3009. Highly regarded stock photo management, Windows.

• StockView III / HindSight Ltd. (888) 791-3770. Widely used, feature filled stock photo management, Windows/Mac.

• fotobiz photo business management, includes Fotoquote. Windows/ Mac

• Agave/Rosette Software 520-749-3988 Feature rich, popular stock management, Windows

• ProSlide II / Ellenco (505) 281-8605

• Cradoc CaptionWriter / Perfect Niche Software (800) 947-7155 Basic captioning and database.

Some of these sites also have pages that describe slide filing systems.

SECRET #52: COPYRIGHT

If you want to publish your photos, you need to understand the basics of copyright law.

The right to copyright is rooted in the U.S. Constitution in Article I, Section 8, Clause 8. This law states that photographs created after January 1, 1978, are subject to copyright protection for the life of the author, plus 70 years after his death.

There are four exclusive rights that belong to photographers as copyright owners, and they can be assigned, sold, transferred or given away. These rights are:

• To reproduce the copyrighted work.
• To display the copyrighted work publicly.
• To prepare derivative works based on the copyrighted work.
• To distribute copies of the copyrighted work to the public.

In layman's terms, if you make a photograph, it is your property and only you can decide how it gets reproduced, displayed, changed or distributed. You can share your photographs with others. You can also sell, rent or show them. You never need permission. But if someone else wants to sell, modify, show or distribute your pictures, then they need your permission. Failure to get that permission can result in criminal or civil penalty.

If you make an original photograph and that photograph is recorded on any media whether it is film or digital, the moment that you click the shutter is the moment that the image is copyrighted. There is no law requiring you to register your copyright with the Register of Copyright's Office, nor do you have to place a copyright notice next to the work in order to create a copyright. While I recommend that you do both of these things, you are protected even if you don't.

The photograph is yours and copyright law gives you a legal monopoly on the use of that image.

You should register your images if you want to receive the full protection of the Copyright Act. For published works, the publisher usually does this. You may also register individually published images. If you're like most photographers, you'll end up registering your work as an unpublished collection. In order to qualify for this less complex procedure, (one form and one fee) your images have to meet these requirements:

• The elements of the collection are assembled in an orderly form.

• The combined elements bear a single title identifying the collection as a whole.

• The copyright claimant in all the elements and in the collection as a whole is the same.

• All the elements are by the same author, or, if they are by different authors, at least one of the authors has contributed copyrightable authorship to each element.

Registration is straightforward. For unpublished works, it merely requires that you file a copy of the photo(s) and the required forms with the U.S. Copyright Office.

The fee for registration is $30. If you register one image, the cost is $30. If you register a collection of 100 images, the fee is still $30.

Published works can be registered as collections but under more restrictive conditions. In the case of published works, you usually have to register each image individually at a cost of $30. You also have to submit two copies of the image, not one, as is the case with unpublished photos.

For more information on copyright, visit (http://lcweb.loc.gov/ copyright/circs/ or www.copyright.gov.) You may also call 202-707-3000 to request registration forms by phone. Forms may also be obtained by postal mail. Contact the Register of Copyrights, Library of Congress, Washington, D.C. 20559.

Copyright Office fees are subject to change. For current fees, check the Copyright Office website at *www.copyright.gov*, write the Copyright Office, or call (202) 707-3000.

Form VA
For a Work of the Visual Arts
UNITED STATES COPYRIGHT OFFICE

REGISTRATION NUMBER

VA VAU

EFFECTIVE DATE OF REGISTRATION

Month Day Year

DO NOT WRITE ABOVE THIS LINE. IF YOU NEED MORE SPACE, USE A SEPARATE CONTINUATION SHEET.

1

Title of This Work ▼ NATURE OF THIS WORK ▼ See instructions

Previous or Alternative Titles ▼

Publication as a Contribution If this work was published as a contribution to a periodical, serial, or collection, give information about the collective work in which the contribution appeared. Title of Collective Work ▼

If published in a periodical or serial give: Volume ▼ Number ▼ Issue Date ▼ On Pages ▼

2 a

NAME OF AUTHOR ▼ DATES OF BIRTH AND DEATH
Year Born ▼ Year Died ▼

NOTE

Under the law, the "author" of a "work made for hire" is generally the employer, not the employee (see instructions). For any part of this work that was "made for hire" check "Yes" in the space provided, give the employer (or other person for whom the work was prepared) as "Author" of that part, and leave the space for dates of birth and death blank.

Was this contribution to the work a "work made for hire"?
☐ Yes
☐ No

Author's Nationality or Domicile
Name of Country
OR { Citizen of _____
Domiciled in _____

Was This Author's Contribution to the Work
Anonymous? ☐ Yes ☐ No
Pseudonymous? ☐ Yes ☐ No

If the answer to either of these questions is "Yes," see detailed instructions.

Nature of Authorship Check appropriate box(es). See instructions
☐ 3-Dimensional sculpture ☐ Map ☐ Technical drawing
☐ 2-Dimensional artwork ☐ Photograph ☐ Text
☐ Reproduction of work of art ☐ Jewelry design ☐ Architectural work

b

Name of Author ▼ Dates of Birth and Death
Year Born ▼ Year Died ▼

Was this contribution to the work a "work made for hire"?
☐ Yes
☐ No

Author's Nationality or Domicile
OR { Citizen of _____
Domiciled in _____

Was This Author's Contribution to the Work
Anonymous? ☐ Yes ☐ No
Pseudonymous? ☐ Yes ☐ No

If the answer to either of these questions is "Yes," see detailed instructions.

Nature of Authorship Check appropriate boxes. See instructions
☐ 3-Dimensional sculpture ☐ Map ☐ Technical drawing
☐ 2-Dimensional artwork ☐ Photograph ☐ Text
☐ Reproduction of work of art ☐ Jewelry design ☐ Architectural work

3 a b

Year in Which Creation of This Work Was Completed
This information must be given in all cases.

Date and Nation of First Publication of This Particular Work
Complete this information ONLY if this work has been published.
Month _____ Day _____ Year _____
Nation

4

See instructions before completing this space.

COPYRIGHT CLAIMANT(S) Name and address must be given even if the claimant is the same as the author given in space 2. ▼

Transfer If the claimant(s) named here in space 4 is (are) different from the author(s) named in space 2, give a brief statement of how the claimant(s) obtained ownership of the copyright. ▼

DO NOT WRITE HERE OFFICE USE ONLY

APPLICATION RECEIVED

ONE DEPOSIT RECEIVED

TWO DEPOSITS RECEIVED

FUNDS RECEIVED

Sample Copyright Form

SECTION THREE – SALES TIPS

SECRET #53: EBAY

If you want to sell your photos via online auction, EBay is the answer. It represents a marketplace of more than 90 million members worldwide.

While you probably won't have any luck selling generic photos, EBay can work for you if you establish a niche.

Right after September 11th, I happened to be at Safeco Field where the Seattle Mariners play major league baseball. I got a great shot of the crowd waving their American flags. I sold several copies on EBay at $40 each plus shipping. Now, that's not a tremendous amount of money, but at $4 each to make the prints, a ten times return on one's investment is still very good.

Here are some tips for selling your photos through EBay:

1) Make sure you develop a good EBay reputation by having a good feedback rating.

2) Describe your product accurately and succinctly.

3) Include ALL of your contact information in your ad.

4) Make sure that you are set up to take Pay Pal: (www.paypal. com)

5) Make it easy for people to do business with you.

I have sold more than 100 photographs on EBay of everything from Safeco Field to fine art nudes. So find and develop your niche and then research EBay to see if they have a category that relates to it. If so, you are in the online auction business.

SECRET #54: LICENSING

Licensing is the way photographers get paid for their commercial images. But to be successful, you must first know what you are selling. You don't "sell" a picture to a magazine or book publisher,

you license it. There are many different kinds of rights that you can license. Here are some of the standard license arrangements.

1) *Work For Hire.* When you shoot "work for hire," you give up all of your rights to your photographs. I recommend NEVER agreeing to this arrangement unless you have a full-time job as a photographer for a magazine or newspaper where they supply your equipment and pay you a salary.

2) *Exclusive Rights.* This means that the buyer can use a particular photo exclusively for a specific period of time. In some cases, exclusive rights are only exclusive within a specific industry category. You may, for example, license a picture of the Grand Canyon to a clothing company and agree that no other clothing company can use that picture. But that doesn't stop you from also licensing it to a professional sports team.

3) *Serial Rights.* These are usually the kind of licensing agreements periodicals want. They will often want to add exclusivity to the agreement. This refers to the first publication of your work in a magazine or newspaper.

4) *One-Time Rights.* The buyer licenses and pays for the image for one-time use. Any additional use requires an additional fee.

5) *First-Time Rights.* This is similar to one-time rights, except that the buyer reserves the right to purchase the photo before any other party has licensed it.

To see sample photographic contracts you can use as a starting point for your own negotiations, visit www.editorialphoto.com/contracts/. (NOTE: You should consider having a licensed attorney review any contract before presenting it to a prospective client.)

SECRET #55: ONLINE PHOTO SERVICE

In addition to creating your own website from which to sell photos online, you can also use an online photo service to sell your pictures. With a photo service such as dotPhoto.com or Shutterfly. com, you set your own prices and payment terms. You can upload

the logo and add it to your site as well as customize the experience for buyers. This option makes your photos publicly searchable and to market them, all you have to do is send e-mail invitations to a mailing list. Another approach is to contact Webshots.com to sell photos as screensavers.

There are hundreds of web sites similar to these. Do your research and find sites that appear to be a good match for the kind of work you do. Contact them and ask for their submission guidelines.

The idea behind sites like dotPhoto.com and Webshots.com is that they will help you build a community of people who are interested in photography. Where there are people interested in photography, you also have the opportunity to sell. I don't advocate doing this instead of building your own web site, but using sites like these can provide additional income.

Here's how you might use these sites to sell more photos. Photograph a wedding and you will certainly sell images to the bride, groom and their families. Then, use online sites like dotPhoto. com to show the proofs to others who attended the wedding or know the couple, and increase your chance to sell.

SECRET #56: CLASSIFIED ADS

Classified ads are an inexpensive way to let people know how to buy your photos. Many magazines, daily and weekly newspapers, and classifieds-only newspapers target both local and national audiences. Depending on what you have to sell (i.e. portrait settings or framed art), you can select venues for your ad that will allow you to appeal to the customers you wish to target. If you make baby portraits, advertise in the sections that appeal to expectant or new mothers. If you sell framed lighthouse pictures, advertise in the boat and home décor sections.

The benefits of classified ads are many. They are:

1) Targeted
2) Easy to test
3) Inexpensive

4) Effective

5) Require zero production cost

To make your classified ad as productive as possible, use a short, snappy, focused headline printed in bold text or all caps. Avoid abbreviations if possible. Be sure to make only a single offer in the ad, instead of including multiple products. Ask the reader to take a specific action, such as visiting your website or calling on the phone. Include your contact information in the ad.

Think creatively when selecting a category for your ad. Above all, be sure to test your ad. Test the same ad in several categories and see which one pulls the most response. Put a code number in each ad so that you can measure the response each one draws.

Finally, when you run classified ads, think long term. Don't run an ad for a week and expect instant results. Instead, advertise three days a week for two months. You must get people used to seeing your ad before it will generate responses.

Here is a sample classified ad. This ad would run in the PETS section of the classifieds.

Looking for a new puppy? When you find that perfect little pal, why not have his "baby" portrait made? Call John Smith Photography at 555-555-5555. We specialize in telling your dog's story with photography. Sitting fees start at only $50. Call today, availability is limited.

Mention code number xxxx to receive a bonus print.

SECRET #57: KNOW YOUR AUDIENCE

There are, generally speaking, four types of art photography buyers. These buyers are described below. If you want to sell your images in galleries, at high-end art fairs or fine gift shops, it helps to be familiar with the differences.

A) The Patron

The patron is the most desirable target for your work. This is a serious collector who understands art and buys it for a variety of reasons, including investment potential or to add to a collection. Unfortunately, patrons are the hardest clients to attract. They tend to buy established photographic artists like Ansel Adams or Edward Weston. They are also sophisticated and very specific when they buy art. Only artists who can match that level of sophistication and the patron's personal field of interest will earn their business. These buyers are less than 5 percent of your total audience; but as a group, they are willing to spend the most money. They are not price sensitive and usually want to buy your print museum-mounted, matted and framed. Patrons should be cultivated. If you get one, contact them on a regular basis. Tell your patrons about your new projects. Patrons do not want to collect from artists who may be out of business in a few years or who have only been one-hit wonders.

B) The Collector

Collectors do not have the sophistication, level of experience or budget of a patron, but they do buy art if it has an emotional appeal. But collectors may evolve to the role of patrons someday. And while collectors are more price sensitive than patrons, they will still spend money for something they enjoy and really want to own. They buy materials framed and unframed but usually prefer to buy nicely matted prints. This group makes up about 5 percent of your audience, and they are good targets for new photographers to develop.

C) The Casual Art Buyer

This person is more interested in buying a photograph that matches the décor of a room rather than for its artistic value. This buyer makes choices based on physical appeal. They buy only occasionally and art is not a high priority for them. These buyers are price sensitive and will buy something because it fits their pocket book, the colors are right or it reminds them of a place that is special to them. Sophisticated art is typically not appealing to them. They are much more likely to buy an attractive picture over an abstract. They tend to not buy framed pieces unless the frame is inexpensive. They may occasionally step up to a matted piece if it will fit a standard size, store-bought frame. Casual art buyers make up about 30 percent of your audience.

D) The Decorator

This is the person who buys art only when they move into a new house, buy new furniture or as an impulse purchase. They are much more interested in whether the picture matches their decorating scheme than anything else. They are extremely price sensitive and tend to want to buy prints that they will frame themselves. These buyers don't care where you went to school or how much effort went in to capturing an image. They are looking for work that appeals to them: attractive images that capture their attention. A large segment of this group is tourists. If you are lucky enough to live near a major tourist hub, such as the Grand Canyon, the west entrance to Yellowstone, Vermont or Cape Cod, you can sell local pictures to these buyers. Decorators want a large selection of offerings in different sizes and colors. They won't buy unless they are immediately struck with something you have to sell. More serious decorators will check back to see if you have added to your collection, Decorators make up about 60 percent of your audience.

If you're just getting started, concentrate on low-price prints targeted to decorators. They are easy to locate, particularly if you have access to a large tourist spot. And they are quick to buy if there is something available that they like. But remember, most of these are one-time buyers.

SECRET #58: SHOWING IN TRADITIONAL GALLERIES

Many photographers dream of selling their photos in a gallery. Unfortunately, the key word in the last sentence was "many." The competition to show in galleries is fierce. It takes persistence, research and a lot of luck to pull it off.

Here are some ways to improve your prospects:

Above all, do your research. Make sure you target galleries that fit your photographic style. If a gallery only shows black and white fine art photos, your color photographs are not going to be accepted. I am always surprised when I find out that many photographers have not visited the galleries where they want to show. I advise visiting many different galleries before you decide to propose a show. Then approach only those galleries that are a good fit.

Most galleries have submission guidelines just as magazines do. Galleries typically require 12 to 24 months lead time to prepare for a show. Depending on the gallery's popularity, shows are sometimes planned years in advance. If you'd like to exhibit work in a gallery, you'll need to plan two years ahead. The successful, established galleries already have their calendar planned that far in advance in order to advertise the shows.

Do your homework and be prepared before you make your submission to the curator. Remember that the gallery is there to make money. They are not judging the merits of your work. They are judging your marketability, personality, professionalism, and attitude. If you do get the chance to show your portfolio, prepare as you would for a job interview. Show only your very best work and try to pick images that are thematic and representative of a successful body of work. Also be prepared for a great deal of rejection. Since competition is tremendous, you will hear "no" more often than "yes." Keep your morale high and keep on trying.

Your local phone book is a great place to start if you want to find galleries in your area. If you want to find galleries in other cities, go to www.switchboard.com.

SECRET #59: WHAT TO DO AFTER YOU GET A GALLERY GIG

You have done a great job of marketing if you have successfully arranged a gallery show. But your job is not over yet. Whether it's in a formal gallery or a coffee shop, there are some things you need to know and do for a successful event.

When you schedule your event, make sure it doesn't conflict with major holidays or local events. If it's homecoming weekend at the local university or the night of the *American Idol* finals, you probably should select another date.

Promote your show by sending press releases to the local media at least three to four weeks before the start of the event and invite them to attend the opening of the show. Notify the local Chamber of Commerce and any local arts organizations. You can find out about local arts organizations from museum and art gallery curators.

E-mail all of your friends and family and ask them to attend and invite their friends. You must also create and distribute postcards, posters, and flyers promoting the event. Invite all of your existing customers and post information about the show on your website.

Treat the opening as an event by creating a nice ambience. Consider hiring a solo jazz or classical guitar player. Place fresh flowers on tables and provide snacks. Connect with the audience any way you can.

Promote yourself onsite. Make sure to have bios and resumes available for guests. Strategically place business cards and brochures throughout the venue. Present an Artists' Statement about the show for people to read.

If you have access to a large television, connect a videocassette recorder or DVD player and present a show of your images. You might also consider demonstrations. Just having your camera there mounted on a tripod will generate questions.

See my sample press release in the Appendix.

SECRET #60: PROPERLY DISPLAY YOUR PRINTS FOR SALE

When you do get an opportunity to show your work, it is important that you make a good impression. Don't skimp on quality. Start with a good acid-free mat. If you can afford it, double mat your images.

Mat with a neutral color. This increases the chance that a decorator-type buyer will recognize the value of the print. If you are hanging monochromatic images, consider using an off-white mat.

Be sure that all of your materials are of archival quality. To be archival, materials must be acid-free and your papers should be rated at 50 years or more by Wilhelm Research (www.wilhelm-research).

If you have unconventionally-sized prints, mat and frame them in standard frame sizes by customizing the inside dimension of the mat to fit the image. This costs a little more to do this but it is far less expensive than having custom frames made. Typical standard photographic frame sizes are 5x7," 8x10", 11x14", and 16x20."

Be sure to use acid-free backing for all of your images, whether you display them only matted and wrapped in cellophane or have them framed. Otherwise, they could deteriorate over time.

Include your contact information and a short biography on a sheet of paper that you insert in the package or attach to the back of the frame. You can even include an order form for more copies of the image. I use a "Certificate of Authenticity" that includes my image title, a short biography, and my contact information. When I started using this certificate at art shows, fairs, and galleries, sales after the show increased.

Pay strict attention to the way the images are displayed. Try to display no more than one image per wall in a small gallery and no more than one image per 10 square feet in a larger gallery. Crowding makes your work look cheap. Try to display under ideal lighting conditions using fingerprint free glass.

See my sample Certificate of Authenticity in the Appendix.

SECRET #61: TRADE SHOW EXHIBITS

Trade shows are great places for photographers to find new business. Almost every booth at a tradeshow needs graphics. Many trade show booths are built with panels designed to hang large, rear illuminated photographic transparencies. This is also great time to sell employee portraits and group photographs of the people staffing the booths. There are opportunities to photograph product shots for subsequent display in the booths, as well as event shots at company parties, press conferences, and other trade show events.

In order to get trade show business, you need to understand the kinds of photos tradeshow vendors buy. Start by visiting two or three large trade shows. Make sure these shows are relevant to your own areas of interest. You will have a better chance of communicating with these companies if you know something about their products and services and take time to learn even more.

Next, get a list of participating vendors from show operators. Be prepared to pay for this list, but it's worth it. You can contact the vendors and pitch them on hiring you to make photos for their next show.

Start by sending them postcards, then follow up with a detailed letter and a phone call. For every 10 companies you call, you can expect one to hire you.

SECRET #62: RESTORATION

A tremendous business opportunity exists for retouchers. Restoration of old photographs that have been damaged, faded, or folded is a very profitable business. With the advent of digital retouching, restoration is now easier than ever before.

In addition, families are often eager to archive their important pictures by having them scanned and then stored on CD-ROMs or DVDs. If you have a computer, scanner, printer capable of making archival prints and a copy of Photoshop, you can archive photos.

I have worked with local insurance companies to restore their

clients' damaged photos. In one case, a woman had 650 photos ruined by flooding. The insurance company hired me to restore the damaged images. And best of all, I developed a relationship with the family that led to several more portrait sittings.

Restoration work can open up new opportunities. While your ultimate goal might be to sell photographs, offering restoration services is a rewarding way to achieve that goal.

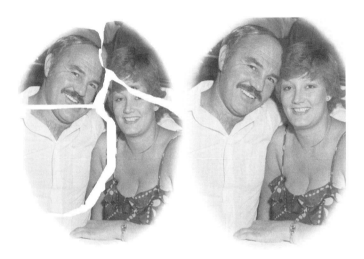

Sample Restored Photograph

SECRET #63: SELL WHEN THE SEASON IS RIGHT

If you participate in art fairs, gift shows, gallery exhibitions or any other venue where you can sell your photography, be sure to be stocked and positioned to "sell when the season is right."

When do most photographs sell? The winter gift-giving season of Christmas through New Year's is prime time for photography sales. More gifts are sold during these few weeks than at any other time. This means that you must have a good stock of prints ready for your local gallery or art fair. People won't buy what they can't see, and

they won't wait for you to make additional copies if you don't have enough inventory.

The second best time to be stocked with plenty of inventory is during the weeks prior to Mother's Day, Father's Day and graduation time. This is the second strongest selling season for the photographic industry. Be sure to have your photo calendars ready to sell by this time. People start buying calendars as gifts in May or June, not just in December.

Other strong gift photo opportunities include Valentine's Day and Easter.

SECRET #64: YOUR GUARANTEE

When you sell prints, always offer a lifetime guarantee. This instills confidence and loyalty in your customers and increases customer satisfaction. It also removes any purchase objection by providing reassurance for any customer who is not convinced that you will deliver on your promises.

I have offered a lifetime guarantee on all of my print sales since 1995. To date, no one has asked me to make good on it. If it ever happens, I will gladly remake the prints.

You can choose to express your guarantee in a variety of ways: money back guarantees, lifetime guarantees, or return privileges. Whatever method you use, make sure that you always mention your guarantee in the sales process.

See my sample guarantee in the Appendix.

SECRET #65: ESTABLISH YOURSELF AS A PUBLIC SPEAKER

Speaking engagements are a great way to sell photographs. Join Toastmasters, your local Chamber of Commerce, the Rotary Club or any local service organization. Seek speaking opportunities at libraries, churches, schools, PTA meetings, garden club meetings, workshops, seminars, and at any other large public event.

You can speak about how to make photographs, how you made a particular set of photographs, the photography industry, photographic equipment or anything else that your local organization might find interesting. Just make sure that you explain the kind of work that you do in your presentation.

Be sure to have a small postcard, greeting card or a print for everyone who attends your speech. And be sure to invite your existing or previous customers to any public event where you are featured to speak.

Be open to speaking whenever you are invited, no matter how small the group. You never know who you will meet or how they may be able to help you advance your career. Increasing the number of people who see your work and know you are a photographer will translate to more opportunities to sell your work.

SECRET #66: SELLING TO CATALOGS

Catalogs are a huge market for photographers. Annually, 7,000 catalogs are published in the U.S. and 1,000 more are available in Canada. Each year, companies distribute 11.8-billion catalogs. Nearly all of these catalogs contain photographs.

While your chance of getting hired to shoot the big catalogs (Sears – handled by a big ad agency) or the cool catalogs such as Victoria's Secret (don't you wish?) are slim, smaller catalogs are relatively easy to break into.

In my area, there is a broadcast supply company that mails tens of thousands of catalogs each quarter. I called on them about shooting pictures for those catalogs. While the product shots were made with the help of an advertising agency, I got the job photographing the people shots for the catalog. It pays well and best of all, its regular work. They call me back every three months to update staff photos and shoot a new group shot of the employees.

To get these jobs, you must develop a portfolio showing product shots and photos of people using different products. You'll need to be able to shoot both indoors and out as well as in a variety of

lighting conditions. It helps to be knowledgeable about the products you are shooting, because you'll have greater insight into setting up appropriate shots.

Research the companies in your area. Call them and ask for their catalog. Then review the types of photos they use and create a portfolio of shots featuring similar images. Ask your friends and family to pose for sample shots if needed.

SECRET #67: ART AND CRAFT FAIRS

Art fairs are hard work, but they are also very accessible to almost any photographer who has the time, money and vision to set up a booth and sell. There are several things that you will need in order to be successful at art fairs. First, you must understand your audience. Make sure that you attend the right art/craft fair for your style of photography. And if people at your local fair typically don't spend more than $10 for a piece of art, don't bring $200 images to sell.

You will need a booth, picture-hanging system, inventory, money box, change, business cards, brochures and patience.

Research fairs in your area, learn their submission guidelines and fees, and apply early. Find fairs in your area by checking the Art Fair Sourcebook, www.artfairsource.com.

The prime booth locations at an art fair are reserved first, so don't wait too late to sign up. You should be prepared to show proof of insurance (usually a business policy will do) and samples of your work, along with pictures of your booth. This assures the fair organizers that you are a good fit for their event. It will also cut the time needed to get approval and the prime space.

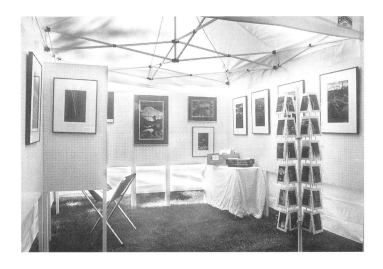

Sample Art Fair Booth – Photo Copyright Rod Barbee

SECRET #68: PHONE COMPANIES AND BANKS

Your local phone company and bank are incredible places to sell photos.

Phone companies are a two-fold target. First, most phone companies are eager to appeal to local customers by supporting the local community. They will buy images from you for display in their lobbies. They will also buy images to publish in their directory.

Banks are another business that want to support the community where they are located even if they are a state or national institution. Thus, banks frequently adorn their walls, brochures and sales literature with images from local photographers.

To prepare yourself to pitch the banks and phone companies, review images that they have displayed or printed in the past. Chances are that if you pitch the same types of images, you will be successful in selling them.

SECRET #69: CHAMBERS OF COMMERCE

No local entity is more interested and more committed to supporting local photographic images than the Chamber of Commerce. They need pictures for their membership directory, their website, for economic development brochures, trade missions, business development, and community public relations.

Local photographers have an advantage over big ad agencies and stock agencies if they can deliver timely photos that show the local images that chambers of commerce like to promote, including families, high profile businesses, shopping, parks, education, recreation and tourism.

Contact several chambers of commerce in your area and ask for copies of their brochures for newcomers. Visit their website and evaluate the images. This is the road map for the emerging photographer who wants to make inroads in the market. If you can make and show the same kind of images that you see in their literature and on the website, contact the chamber's marketing communications director and ask for an appointment to show your portfolio.

If you visit a city other than your own, take along the same pictures that you would take in your own home town and arrange for a showing. I did this while teaching a workshop in Oregon a few years ago and successfully licensed eight images.

SECRET #70: HIRE AN AGENT OR REPRESENTATIVE

If you do not want to spend a significant amount of your time selling your work, you need to hire someone to represent you. We call these people "agents" or "reps."

Typically, reps earn a commission on the sale of your work. So you will have to demonstrate to a rep that your work will sell and that you are a worthy client. Reps are looking for photographers with talent. You must demonstrate talent and ambition in order to attract an aggressive rep, who will do the most he can to sell and promote your work.

A rep doesn't want to waste time promoting your images only to find out you've moved to another career or decided to produce new images every six months. Reps want to represent photographers who are professional and trustworthy. Arrive at your appointments on time and meet all deadlines. Take care to fulfill business obligations. The rep wants to know that you can be trusted to fulfill your part of the agreement.

To find a rep who is willing to represent you, you must demonstrate success selling images on your own to significant markets. Good reps will not work with rookies or brand new photographers. And, make sure that you can compete with the other photographers who already have representation.

The Society of Photographers and Artists Representatives (SPAR) located in New York City is a great place to begin looking for a rep.

Another place to find reps is by placing ads in magazines such as *Photo District News* and *Communications Arts*. Start by picking up copies of these publications from your local newsstand and review the kind of photography they publish. This will give you a good idea of the current standard that you have to meet before you can attract a rep.

If you are just starting out and can't compete for a national rep's attention, consider hiring a local college student who is pursuing a sales or marketing degree.

Finally, you should expect to pay a rep between 17.5 and 25 percent for projects they bring in on their own and slightly less if you get jobs as a result of co-marketing. The payoff will be jobs that you can't get otherwise, since some publications only deal with reps, and more prominent, higher paying assignments.

SECRET #71: CLOSING THE DEAL

Failing to ask for the order is the number one reason why most photographs aren't sold. Pay close attention to this statement since it means the difference between your success and failure.

You pitch a bride on hiring you for her wedding. You offer to license images to a local corporation for use in their catalog. You try to get your pictures placed in an important calendar. You've done your homework; dressed up, made an impressive presentation and you have received positive feedback from the prospect. The next step is to ask for the order.

There are several statements you can use to close the sale. I recommend that you memorize these statements and practice saying them in front of a mirror. Start with a trial close. "Do you like my work, Mrs. Smith?" "What do you think of our packages?" "Is this the kind of photography you are looking for?"

Answers to these trial closes provide a clear signal about the prospect's interest in your proposal. Trial closes allow you to uncover objections or issues you still need to overcome before you can make a sale. If you get positive signals, move on to the close.

My favorite close is called the assumptive close. This is based on the "assumption" that the client plans to say "yes." From the moment I start this close, I treat this deal as "sold." I wrap up my presentation and have a contract ready that reflects the terms I have offered. At this point I simply hand the contract to the prospect and say something like, "Okay, all that's left is for you to sign this agreement." Then I hand it to the buyer and keep my mouth shut.

I used to be somewhat timid about this until I realized that in almost every case the buyer just proceeds to sign it.

If you don't want to be this aggressive, try something simple such as, "Would you like to buy my photos?" or "Would you like to hire me to photograph your wedding?"

At some point in time you need to ask the buyer for a decision so that you can move on. And chances are if you ask for the sale, you'll get it.

SECRET #72: CO-OP GALLERIES

If your goal is to break into gallery sales, cooperative galleries offer an ideal opportunity for emerging photographers. Co-op galleries require the artists they represent to share in the expense and overhead of the gallery's operation. Sometimes they require artists to help offset expenses by paying a fee to show their work. Others require a commitment to staff a shift in the gallery each week. And some co-op galleries require a combination of both.

The basic concept is that non-competing artists can be more successful by working together to sell each other's work.

If you have never exhibited and hope to break into commercial galleries, co-op galleries, or artists' associations are an excellent place to meet leaders in the local art community. Many commercial gallery curators will attend shows at co-op galleries looking for new talent.

Co-op galleries also represent a great place to test new themes or shows to ensure that you are generating the public interest you expect. If you exhibit 10 pieces and only half of them generate interest, it is probably time to re-evaluate your show before pitching it to larger and more established commercial galleries.

A side benefit to co-op galleries is that you get to interact with and learn from artists who are at the same level in their career as you. This is invaluable experience since it helps you to see things from a different artistic perspective.

Be careful not to fall into the trap of exhibiting in vanity galleries. Vanity galleries are nothing more than money makers for their owners. Vanity galleries have no real interest in your career or success. Their interest ends with the fee you pay to exhibit with them. The way to spot a vanity gallery is to look for a gallery where competing artists are allowed to sell side-by-side. Also note that these galleries are strictly fee based. You rent space and pay to set up your show. They pay for nothing. Vanity galleries will also let anyone in who can pay and rarely have an established client list. If you spend a day at a vanity gallery, you probably won't see sales.

Look for co-op galleries that have achieved a good reputation in the art world.

If you have retail business experience and the financial resources to do it, you may want to consider starting your own co-op gallery. Meet with other local artists and explore their interest. Then begin looking at some of the prominent co-ops in the major art markets in New York, Chicago, and Los Angeles to see how it is done.

SECRET #73: DAY RATES

Many photographers who shoot for magazines or for big corporations charge what is known as a "day rate" for their services. This is simply a flat fee that entitles the client to use any photo or photos made on a specific day for one specific project or additional projects if so negotiated. A day rate is simply an assignment fee tied to specific reproduction rights. It means that you will agree to produce photographs for the client's use and in return will be paid a flat assignment fee. While the practice of charging day rates was established by Madison Avenue photographers, it can still be a valuable tool for the emerging professional.

Charging a day rate can make some buyers feel more comfortable if they are concerned that an hourly rate will be drawn out or if they don't want the burden of additional accounting that goes along with space rates (where the photographer is paid by the column inch or on a per shot basis). Day rates are package deals and they make business arrangements easier for both parties. But be aware that day rates can be limiting. Savvy buyers will try to negotiate half-day rates when they only need a few photographs. Resist these arrangements. Instead you should insist on a full day rate regardless of the type or length of job. Even when the client claims to only want a few shots, there are always unexpected things that can consume your time. You may, for example, spend all day waiting for the best light, and you should be paid for all the time you spend on the job. After all, the buyer has already received a discount by negotiating a day rate or "package" deal.

The same licensing considerations you would have in effect when you charge by the shot or by the inch still apply. Charging a day rate does not mean that you give up all rights to the images. Negotiate a limit on the usage and include a fee structure for use outside the original agreement. The amount of the rate will vary depending on the rights your client wants and market conditions.

Always use day rates when you are negotiating with buyers who are more experienced than you are. It will make you appear more experienced and buyers will be less likely to try to take advantage of you. Just be sure to quote a day rate that is high enough to compensate for your expenses, your salary, and taxes.

SECRET #74: SELLING ON CONSIGNMENT

Selling your photographs on consignment is one of the safest ways to start earning money as professional photographer. If you have the time, you can ask galleries, gift shops, book stores, craft shops, antique stores, art boutiques, gift shops, coffee shops, restaurants and frame shops to display your photos and pay you only when a sale is made.

Expect to pay a commission of as much as 50 percent for consignment sales. Also expect to have to earn your way into these shops. While it may be a "no-lose" situation for them, remember that other photographers will have the same idea and your work needs to stand out and sell in order to receive top billing.

Some consignment shops that sell art will want to review your work to decide whether it's right for their store. When you sell on consignment, you should expect to continue to actively market your images. In most cases, you will still need to advertise and promote your photos. So choose locations where you have the best chance of success. If you take photos of the seashore, boats, or marine life, you may want to target shops located in areas near seaports, or where there is strong interest in local photos.

Make sure you have a contract with the consignment shop. This will make it easier to get paid if your work sells. It also helps prevent misunderstanding over your payment terms.

You can get a sample art consignment agreement here at www. allworth.com/Pages/standa.htm.

SECRET #75: ADVERTISING SECRETS (Part 1)

Generally speaking, customers aren't very good at extra sensory perception (ESP). You can't rely on hope and good karma to draw customers in to buy. You must advertise in order to:

· Attract new customers
· Reduce the time involved in the buying cycle
· Create a dominant market position
· Introduce new products or services
· Boost productivity
· Enter new markets
· Educate customers
· Retain existing customers
· Thwart your competition's advantage
· Establish credibility

Write ads that sell one simple concept. And make sure that you don't miss the market. For instance, a pizza restaurant that relies heavily on delivery to gain business has a choice when they write ad copy. They can choose to sell pizza in the ad or they can choose to sell their phone number. Since the phone number is the necessary first step to ordering out, the phone number is the most important thing to advertise. This kind of thinking helped Pizza Hut become one of the dominant brands in North America. Listen to their commercials. It's the phone number that they keep hammering, not the quality of their pizza.

When you're selling photography, don't just think pictures. Think about the emotional draw of photography. Sell that over pictures.

SECRET #76: ADVERTISING SECRETS (Part 2)

In order to create appealing advertisements, you need to understand the concepts that encourage consumers to buy. Your ad campaigns should be based on these concepts. To make these concepts work, imagine how your customers feel. Appeal to your customer's needs.

Find out what they want and communicate it thoughtfully and creatively.

Here are some words and concepts that typically appeal to photography consumers.

· Good taste
· Beauty
· Attraction
· Family
· Well being
· Community stature
· Happiness
· Romance
· Rest
· Eternity
· Security
· Peace
· Memories
· Storytelling

Now, to make these concepts more powerful, weave them into a strong ending for your ad copy. Use these concepts to wrap up any of the following:

1) Tell people how they will benefit from your photography.

2) End your ad with a question that requires a yes.

3) Sprinkle these concepts through your entire ad and then sum up with the most powerful.

4) End your ad with a guarantee or testimonial.

5) Create urgency by putting a timeline on your offer.

SECRET #77: ADVERTISING SECRETS (PART 3)

When you are writing copy for a newsletter, brochure, postcard or an advertisement, be sure to concentrate on the things that your prospect finds important, not what you find important. Here are some ways to accomplish that objective:

• Do your research – know your own strengths and those of your competitors.

• Tell the audience what you're going to tell them, give them the information, and then tell them what you told them again.

• Focus your message on benefits – not features.

• Limit your message to one big idea.

• Make sure that your copy is accurate and believable.

• Make sure you tell how you are different. Have unique selling points.

• Write so that the audience knows what your offer means to them.

• Keep your copy brief and tight.

• Keep your message upbeat.

• Don't attack your competition.

• Always have an offer that is easy to understand, and then ask for the order.

Here is a sample feature-based ad:

"Are you looking for a new portrait? We use state-of-the-art cameras on Hollywood-quality sets to produce your photograph."

Here is a sample benefits-based ad:

"Is it time to capture the way you look in a portrait? We use technology that will accentuate a youthful appearance, while ensuring that your friends and relatives still see the real you. Our studio is warm and comfortable, and our backgrounds are designed to bring out your best features."

SECRET #78: FINDING NEW CLIENTS AND MARKETS FOR YOUR WORK

It's not enough to just start a business. You have to grow it. That means you can't be satisfied with the clients you presently have. You must constantly strive to gain new business. Here are some tips for finding and selling new business.

• When working with a new prospect, focus your efforts on satisfying their needs. The potential client doesn't care how wonderful you are. They just want to know how they will benefit from your photography.

• When you pitch a new client, show your best work first. If you don't immediately capture their attention, you'll never get it.

• Don't show too many pictures. Your best 10 or 20 should be all you need to get most jobs.

• Maintain eye contact during your presentation and use the client's name at least twice during the pitch.

• After you have made your presentation, make sure the prospect knows exactly what action you want them to take, such as place an order or set an appointment. Always ask for the order again.

SECRET #79: STUDIO OPEN HOUSES

If you work out of a studio, schedule a weekend open house. People who buy or collect art love to visit you and see where it is made. It helps them feel connected to the artist. Prospective brides like to meet local wedding photographers before they choose one.

Open houses are most effective when they are tied to special art events such as art walks or community themes. They are also effective when scheduled regularly. For example, you can schedule an open house every other weekend or the third Saturday of each month. Try to pick times that coincide with your clients' time off from work.

Send news releases announcing your open house. Print postcard invitations and send them to regular clients, the news media, and vendors. Have simple snacks along with your best work. Frame, mat, mount, or display all of your best images. Treat it like a gallery show.

Post prices on your work and be prepared to take credit cards. If you can arrange to have an assistant or friend help with your open house, it will be easier to visit with clients and track their interests. If you photograph weddings and portraits, have a special gift certificate offering a discounted sitting fee.

Demonstrations in your studio will keep and hold interest longer than just showing pictures. I like to have a camera with a long lens (always draws attention) set up on a tripod or a Photoshop demonstration prepared for an on-the-spot demonstration. When I demonstrate during an open house, patrons spend more time and money with me.

SECRET #80: WEDDING PHOTOGRAPHY

If you want to sell wedding photography, you need to find prospective brides. First look in local newspaper. Most brides will post an engagement announcement. Look in the newspapers to find a list of people who have applied for marriage licenses. Newspapers list engagement announcements. If you are resourceful, you can use

that information to obtain mailing addresses or phone numbers to market your services to these engaged couples. You can also identify brides by looking through church bulletins that announce upcoming marriages.

You can find mailing addresses on switchboard.com, or you can look in the telephone directory.

Once you have a name and address, send a postcard or letter, or make a phone call. Invite the couple to view your portfolio or visit your website. Ask them to consider hiring you as their wedding photographer.

Another way to reach potential wedding photography clients is to contact the county clerk or registrar. (Their phone number should be listed in the Government section of your local phone book.)

Each municipality has their own laws and rules. Almost every city, county or state requires couples to obtain marriage licenses.

Sometimes you can buy a list of licensees or get it for free. Some government agencies require that you pay a minimum copy charge. You can market to those people with e-mail or postcards, although be very cautious if you send personal e-mails. No one likes spam.

SECRET #81: SELLING THROUGH YOUR OWN WEBSITE

Consumers are becoming very comfortable shopping for everything from cars to houses on the Internet. Photography buyers are no exception. For that reason, you must have a website.

Here are some of the things that you can do with your website:

- Introduce people to you and your work.
- Publicize your photo business.
- Sell your photos directly to customers.
- Direct customers to galleries and other retail outlets that sell your photos.

In addition to selling photos on your website, you can use it to provide customer support, build mailing lists, survey your customers, provide information, or to publish a newsletter about photography.

Once you have built a website, you need to implement a marketing plan to draw visitors to it. There are a dozen things that you can do to promote your site.

• Add your URL and e-mail address to your printed business stationery, marketing materials, and your invoices.
• Add a signature line (that contains your web address) to each e-mail you send .
• Submit your web site to all the major search engines including www.yahoo.com, www.google.com, www.altavista.com, www. excite.com, www.hotbot.com, www.lycos.com. www.webcrawler. com.
• Send your website URL to web-based news services such as www. cnet.com.
• Publicize your web site with all of the photo magazines, local newspapers, radio, and television stations.
• Advertise your site online with services like Google Adwords.
• Post messages about your site to online Newsnet services (Usenet or Newsnet is a computer discussion forum that is topically based).
• Submit your site for an award.
• Join a web ring (a group of similarly situated websites).
• Cross link with other photo websites.
• Participate in a banner exchange with a site similar to yours (you put an ad for their site on yours, and they do the same for you).
• Start a blog for your photography business.

You can also use your website as a way to sell images, particularly if you can make the website very focused. For example, I have a website called wildlifeshooter.com that displays nothing but images of wildlife.

A major mistake that many photographers make when they sell photographs online is to try to do too much. They try to sell every image they've ever taken. By segmenting your website into different genres such as nature, wildlife, fine art, or portraits, you can

communicate a more precise message and target your customers more accurately.

I use different websites to market my photography business and sell prints.

The good news is that websites are really inexpensive to create. You can spend anywhere from a few dollars per month to thousands of dollars. And it's very easy to launch a website. For less than $20 dollars through (www.BIGFolio.com), you can have an attractive site that is easy to maintain yourself, even if you are not a programmer.

(Mention Scott Bourne and you can get half your set-up fee waived.)

This low price will buy you a very basic website, but it will be a way for people to look at your work and find you.

To see an example of a more sophisticated web site, look at my site: (www.wildlifeshooter.com). The photos pop up in separate windows and can't be copied with a simple right click of the mouse. The site also uses Flash (a software program that allows moving images and sound to display on the web) and a shopping cart.

Whatever you do, put your very best images online, and you're in business.

Remember that many of the free web providers sell space to many people. Sometimes, their servers are slow, and your users will be forced to wait, get frustrated, and leave your site. By having a limited number of pictures to show, you will have a faster download speed. From a marketing point of view, there is also a side benefit: it makes it easier for people to see what you have for sale and gives you a place to share your best work.

SECRET #82: YOUR PORTFOLIO IS YOUR BEST SALES TOOL

One of the best strategies to get published or sell images is to present a high-quality portfolio. Showing a portfolio used to mean having a physical book that contained your images. Today, you have multiple options to present your portfolio to potential clients or publishers. Portfolios can be presented on CD-ROM, DVD, videotape, or on a website, as well as the old-fashioned book filled with prints.

Compiling a portfolio requires some planning. First, identify a representative body of work you can use to construct your portfolio. If your clients are looking for motor sports-related images, don't show them nature photography. To do so only confuses the motor sports message you are trying to deliver.

If you shoot nature and wildlife photos, pick a niche that represents the specific type of photography you want to do and sell. By the way, it's easier to sell wildlife than generic nature photographs. Wildlife photos have the advantage of a living, breathing creature being the focus. In my portfolio, I don't show any pure nature pictures, even though I have taken and sold many nature images. My goal is to get more wildlife assignments, so that is what I show in my portfolio.

Whatever you do, don't show photos that you don't enjoy taking. If you do, you'll generate more business for the type of photography you don't want to do.

When it comes to reviewing work for publication or sale, buyers should be able to quickly identify the photographer as the maker of the images. There needs to be a style, a vision, or feeling that makes you unique.

Look, for example, at the work of famous landscape artist, Ansel Adams. If you see one of his images, you'll recognize it immediately as his work. Adams had a definite style and methodology. Because of that, his work is distinctive.

Commit to developing a style and showing that style in your portfolio. Be consistent in your presentation, and you'll enhance your ability to sell.

SECRET #83: FOLLOW-UP (PART 1)

Following up is one of the most important things you can do if you want to sell or publish your photos. Buyers receive many submissions, so it's likely your proposal won't be at the top of their mind. You must set up a follow-up system that is a part of your overall marketing plan so you don't miss opportunities. Make it as automatic as possible and a standard part of your marketing procedure.

From the moment you make first contact with a photo buyer or publisher, you should have the next six contacts scheduled. If your first contact is via letter, you should follow up with an e-mail, and then vary the contact method. Use phone calls, a personal visit, fax,

second personal letter, postcards, and finally a next-day air package if appropriate. The more times you contact and put yourself in front of a photo buyer, the more likely they will think of you when they need something. And that is how sales are made. It's not so much whether you have a great photo; but rather, whether you have a great photo that meets a need at a particular moment. Multiple contacts and follow-up increase your chances for success.

Frequent contact will help buyers get to know you and become more comfortable with you and recognize your work. But use common sense and don't become a pest. Once a month is sufficient to gauge the buyer's interest.

Always follow up your leads within 24 hours of receiving them. If you fail to contact them for a week, they may have already purchased the photos they need from another source.

Always follow up multiple times. Italian economist Vilfredo Pareto created a mathematical formula in 1906 that has been applied over the years to many areas of business and economics. According to the 80/20 rule, 80 percent of sales are made after seven or more contacts.

If you think you'd prefer to follow up by phone with editors, make sure that you respect their deadlines and call when they are least likely to be busy. Note that it is usually not appropriate to call unless you have some relationship with the editor. That said, the aggressive photographer is likely to connect more often.

The best time to reach editors by phone is usually early in the morning. I try to call them before 9 a.m., since most of them arrive at work early. Alternatively, many editors eat lunch at their desks, so that is also a good time to reach them.

If you live on the west coast, you can make calls at 10 a.m. PST and find editors at their desks at 7 a.m. EST.

When it comes to submissions, be respectful of the editor's time. I have visited editors who have more than 200 unopened packages on the floor of their office. As far as your packages are concerned,

my advice is that you do not use any staples and use only use one piece of tape to seal your packages. Avoid the jiffy bags that have the fluffy, flaky cardboard material in them that gets all over the floor when you open them. You can leave a better impression by making their jobs easier.

Make friends with the editor by trying to solve their problems, and above all else, pay attention to their deadlines. This always makes you look more professional. Nothing is more annoying for an editor than to receive a Christmas piece in November. The deadline for that story was back in September.

SECRET #84: FOLLOW UP (PART 2) - RULE OF SEVENS

Contact your prospects at least seven times. Most experts agree that you need to plan at least seven contacts in order to stand out. Buyers may end up contacting you because they've seen your name on mail or in messages enough times to think they know you. Don't be a pest, but be persistent and use different means to contact them: mail, e-mail, fax, and phone.

SECRET #85: GETTING PAID

Getting paid is part of selling and getting published. To get paid, you need to have a contract. Most publishers will use a document called a "delivery memo" to establish a contract. Most editors also have standardized pay rates for photography. They may even publish these rates with their submission guidelines.

So you should send a delivery memo with your submission that outlines your terms. But be careful, if your delivery memo is too restrictive, the editor is likely to reject you. I suggest a simple delivery memo that identifies you, the photos you've sent, where you sent them, and your request for payment and usage language.

Most buyers will pay upon publication. That means you get paid when the magazine hits the shelves. Unless you are in a position of strength, just opt to receive the standard pay rate. Even the most famous photographers don't often try to negotiate with magazines. Magazines pay what they pay. Find the ones that pay well.

Keep your delivery memo short and friendly and deal only with established and reputable publications. You will usually have no trouble getting paid.

Another way to get paid is by registering the copyright on your images. This way, if publications use your photos without your permission, you can take legal action against them.

While it is unusual not to be paid by a publication, it is common to have to wait for your money. While getting paid is not usually a problem, getting paid PROMPTLY can be a big problem.

The best way to get paid promptly is to be clear up front about what each party expects to give and get in the transaction. Be sure to nail down the basic terms in writing and stay in contact with the client. Be assertive about your billing practices. If your publisher is late in sending your fee, send him a second notice (or dunning) letter. This is a written request for payment. If the publisher doesn't respond within 10 days, write them another dunning letter. Repeat this process at least twice before following up by phone.

If you want to protect your business relationship with a slow-pay publisher, you have to weigh how important quick payment is versus the long-term business opportunity. Personally, I try to negotiate a reasonable payment schedule when the job is assigned. If the publisher says something like, "Well, we try to pay within 30 days but our accounts payable department is slow so you should allow at least 60." Then I take them at their word and wait 60 days before I follow-up.

If you just can't get paid, and have exhausted both letter and phone follow up, you should consider hiring a collection agency. For a percentage of the bill, the agency will go after the delinquent account and possibly try to take the offender to civil court. This action is the course of last resort as it means a certain termination of your relationship.

SECRET #86: ALTERNATIVE MARKETS

Think beyond the traditional markets to find venues for your work. Galleries and gift shops are good markets, but there are lesser-known places to consider. For example, photographers have had success selling images in supermarkets, floral shops, gourmet shops, camera stores, airports, art supply stores, military post exchanges, doctor's offices, print shops, frame shops, and specialty shops.

To reach these markets, you must do the leg work. And you need to approach alternative markets on their terms, not yours. The best way to successfully approach these alternative markets is to simply contact them and ask them how they do business. For example, if you sell pictures in galleries, you may be used to giving the gallery owner a 50 percent commission of any sale. Did you know that most supermarkets only require a 20 percent commission to consider an item to be profitable? It pays to know discounts, payment and business terms, and consumer interest for each market.

You can and should use a variety of methods to reach alternative markets. In addition to contacting them directly, you can try to contact them through their sales representatives. Attend their trade shows. This will provide insight into how these organizations do business. Also read the trade magazines that cater to these markets. Find out who distributes the products that are bought and how you can get your photography included in the distribution chain.

Look for cross-merchandising opportunities. For example, if you have great seashore pictures, you might cross promote with a local fish market, including one of your prints free with every purchase of $50 or more. If you have pictures of famous athletes, try selling them in local sporting good stores.

SECRET #87: PREMIUM AND INCENTIVES

A little known photo sales opportunity is the premium and incentive market. Businesses spend $30 billion a year on incentives and premiums for their customers, vendors and employees. And since art photography has a high perceived value, its worth more than other premium products.

There are several types of incentives:

1. Dealer incentives are often used to reward vendors who successfully market their client's products.

2. Sales incentives reward employees who meet certain standards.

3. Businesses and vendors give gifts to their top clients.

Sometimes companies will buy photographs to give to employees at company celebrations. Premium gifts of photography can also help you build name recognition.

Earn other premium sales by providing photographs as contest prizes, gifts for frequent buyer programs and customer loyalty programs.

Here are some starting points to find premium and incentive markets:

CORPORATE MEETINGS AND INCENTIVES
60 Main Street
Maynard, MA 01754
www.meetingsnet.com

INCENTIVE
355 Park Ave. So.
New York, NY 10010
www.incentivemag.com

PROMO MAGAZINE
11 River Bend Dr. S.
P.O. Box 4225
Stamford, CT 06907-0225
www.promomagazine.com

SECRET #88: IDENTITY MATTERS

If you want to get published, you will need a professional identity. Work with professional designers to create a custom logo, business card, letterhead, return address label, and envelope. Then hire a professional to design and print these materials. It's not expensive to get one- or two-color ink printed on white paper from one of the many different quick print companies. When you communicate with editors by sending them submissions, invoices or delivery memos, you'll look professional and distinctive. When your submission is created on professionally designed materials, editors and clients will treat you professionally. They will pay more promptly, respond more quickly, and feel positive about publishing your images.

If you need to find a designer, visit http://www.elance.com. It's a community of freelance designers, illustrators and artists. You can place a job on the eLance site, and people worldwide will bid on it. You will have to do some due diligence, check references, and look at their portfolios before you make a final choice. You can expect to pay between $200 and $500 to have someone prepare your designs, but it is money well spent. It's much better to use a real logo rather than clip art. And what happens if a competition uses the same piece of clip art? It may cost you business due to misunderstanding or misidentification. Someone else may end up wrongly getting credit for your work.

Once you have established your professional "identity," buy the nicest stationery you can afford. If you work from your home and don't want to give out that address, get a post office box. You also will need a physical shipping address to receive FedEx or UPS packages. For anyone just starting out, I recommend using a post office box. If your business grows, you won't have to pay for new printing each time you move.

Scott Bourne
Photography

Some photographers just take
pictures, we tell stories.

3206 50th St Ct NW
Suite 105C
Gig Harbor, WA 98335
scott@scottbourne.com
www.scottbourne.com

253.851.6004 voice
800.819.1179 toll-free
253.851.2241 fax

Sample Business Card

A PPENDIX

Sample Resume

Resume Of Scott Bourne
Scott Bourne Photography
3206 50th ST CT NW Suite 105C
Gig Harbor, WA 98335

SUMMARY OF QUALIFICATIONS

I am an expert photographer who is trained and practiced in all aspects of photo imaging technology including digital imaging, digital capture, manipulation, retouching and printing. While I use state-of-the-art digital cameras for all my photography, I am also well versed in a variety of traditional photographic techniques.

EDUCATION

University of Washington MFA/PHD program - 2004-Pending
Winona International School of Photography - 1998
New York Institute of Photography, Diploma – 1997
Taos School of Art - 1996
Indiana University, Bachelor of Science – 1977

SELECTED SHOWS AND AWARDS

*St. Paul Art Crawl
*South Sounds Arts Commencement Gallery
*Winter Visuals, Gig Harbor, WA
*Larson Gallery 27th Photo Exposition
*107th Annual International Exposition of Photography
*Northwest International Exhibition of Photography
*Art Concepts on Broadway Tacoma
*Art Concepts Kirkland
*Roth Gallery Minneapolis
*Taos Art Guild
*James Gallery Colorado Springs

Merit Winner-Professional Photographers of America, Professional Photographers of Washington, Pierce County Professional Photographers Association

First Prize-Natural State Images, Unique Photo Contest
Second Prize-Popular Photography Contest
Gold Medal-Western States Print Competition
Selectee-World In Focus
Photographer of the Year-WPPA

PROFESSIONAL EXPERIENCE

Executive Director – Olympic Mountain School of Photography 2001-

Editor – Photofocus Magazine 2001-

Owner Scott Bourne Photography 1978-

MAGAZINE CREDITS:

PC Photo, Photoshop Fix Magazine, Studio Photography & Design, Photofocus, Net Guide Magazine, Nature Photographer, Photovision Magazine, Partners Magazine, Photo Insider, Popular Photography, WEVA Magazine, PhotoMedia and *Photographer's Forum*

NEWSPAPER CREDITS

Indianapolis Star/News, Tacoma News Tribune, Tacoma Weekly, Tacoma Reporter, Peninsula Gateway, Port Orchard Independent and *Bremerton Patriot*

PAST/PRESENT DESIGNATIONS & AFFILIATIONS

• Past President - Washington Professional Photographers Association

• National Association of Press Photographers

• North American Nature Photographers Association

• National Association of Photoshop Professionals

• PPA Certified Professional Photographer

Sample Guarantee

OUR PROMISE OF EXCELLENCE!

Thank you for purchasing photographic services by Scott Bourne.

You will be 100% satisfied with the photographic session experience and the resulting portraits at the time of delivery or we will re-shoot and reprint at our expense until you are satisfied.

If you buy prints from Scott Bourne Photography, your print is guaranteed against all defects for your lifetime.

In the event that your print is ever damaged, destroyed or otherwise made imperfect, just bring us the print and we will replace it free of charge during your lifetime, no questions asked.

Scott Bourne Photography guarantees every product and service we sell. Period.

Sample Certificate of Authenticity

Scott Bourne
Photography

This Certificate does hereby Certify that the following print:
"Crooked Nose Canyon"

...is an authentic, handmade, limited edition
photograph from the Slot Canyons Collection
by Scott Bourne

This edition consists of 100 prints.

This is issue 89 of 100.

Dated this 5th day of December, 1998

This print is unconditionally guaranteed for the lifetime
of its original owner.

www.slotcanyons.com

Scott Bourne - Maker

Sample Press Release

Scott Bourne Photography & Digital Imaging
625 Commerce Street
Suite 500
Tacoma, WA 98402

sbourne@f64.com
www.f64.com
www.scottbourne.com

253-428-8258 (Office)
253-312-7223 (Mobile)

Toll Free
tel. 888-557-3111
fax. 888-705-8039

New Photo Studio & Gallery Opens In Downtown Tacoma

(Award-winning digital imaging specialist relocates to Puget Sound)

Tacoma, Wash. -- November 12, 1997

For Immediate release

Scott Bourne, owner of Scott Bourne Photography Digital Imaging, has leased the entire fifth floor at Old City Hall, 625 Commerce Street in downtown Tacoma. The nearly 3000-square foot space has been renovated and converted into a photo studio, gallery and digital lab.

Bourne is a graduate of Indiana University and the New York Institute of Photography. He has also attended the Taos Art School and the Winona International School of Photography, sponsored by the Professional Photographers of America.

He works in both 35mm and medium formats, color and B&W. Most of his work is output digitally using several types of scanners, Photoshop and dye-sub, ink-jet and laser printers.

Bourne is president of F64, one of the first online photo galleries in America. F64 is the result of Bourne's desire to mix his life-long love of photography with his knowledge of the Internet.

Bourne is a member of the Washington Professional Photographers Association, the National Association of Photoshop Professionals, the Professional Photographers of America, the Photographic Society of America and the American Society of Picture Professionals. His award-winning work is featured in national magazines, galleries and in private collections throughout the United States.

For more information contact Scott Bourne at 253-428-8258; sbourne@f64.com or Jana Bourne, Avatar Digital Media, 253-265-2982; jbourne@avatar.net.

Sample Query Letter

Scott Bourne
3206 50th ST CT NW
Suite 105C
Gig Harbor, WA 98335

DATE:

Dear PUBLISHER: (Learn the name of the person who reviews query letters and address this letter to that person by name.)

There are more than 10,000 members of the U.S. Lighthouse Society and approximately 50,000 members of various state and local lighthouse societies. More than 10,000 American businesses have the word "lighthouse" in their name. There are approximately 250 national, state and regional lighthouse societies and another 500 lighthouse clubs. There are thousands of websites devoted to lighthouses and one national magazine.

With all this interest in lighthouses, I am convinced that my book Washington Light, a photographic essay about Washington's lighthouses, will appeal to a wide variety of people who share a passion for these beacons on the coast.

This book is the only book of its kind. While there are lighthouse guides and maps, lighthouse history and textbooks, there are currently no accurate photographic records of every Washington lighthouse.

With 25 lighthouses to its credit, Washington has more lighthouse museums, than most states.

My wife and I have written numerous magazine and newspaper stories, worked for trade publications and published several online journals, but no project we have ever worked on has brought us closer to our audience than this one. While making images for this project, we have been approached by countless lighthouse fans that are excited to learn that a book featuring great photos of Washington lighthouses is in the works.

The book would ideally be 8x11.5 inches or larger trim size soft cover book with approximately 80 pages including 25 full color photographs, 25 poems and 25 quotes. The poems will have a lighthouse theme and be written by Washington poets who have responded to a contest. The quotes are all public domain and have been researched by Jana Bourne, a former newspaper reporter. Scott Bourne will make all the photographs.

Every Washington lighthouse will be photographed several times. From hundreds of photos, the photographer will select 50 images, two of each lighthouse. The publisher and photographer will work together to select the best image of each lighthouse for inclusion in the book. All images will already be in digital format and ready for printing.

The book is already more than one third completed. We expect to finish the book by December.

We look forward to working with you on this project and invite you to contact us any time you need additional information.

Thanks for considering our proposal.

Scott Bourne
Jana Bourne

253-851-6004
info@scottbourne.com

RESOURCES

(NOTE: All web addresses were accurate at the time this book was written.)

B&H Photo

The number one retail photography store in the world. Great selection and low prices. You can get everything from cameras and computers to film and enlargers.

http://www.bhphoto.com

FotoQuote Software

Helps you price your images in a variety of situations. Forms, tracking, and a variety of tools for the working photographer.

http://www.fotoquote.com

FotoBiz Software

Business management software for photographers.

http://www.fotobiz.net

InView and StockView Software

Helps you organize your images, do stock management, keep track of submissions and run the business side of your photography business.

http://www.hindsightltd.com

American Society of Media Photographers

A professional organization for stock and assignment photographers.

http://www.asmp.org

Society Of Photographers, Artists and Representatives

Organization of photography reps.

http://www.spar.org

Wedding And Portrait Photographers International

Society of professional wedding and portrait photographers.

http://www.wppinow.com/index2.tml

Photo District News

A magazine photographers interested in the New York photo scene.

http://www.pdnonline.com

Light Impressions

Albums, display boxes, frames and other ways to display your photos.

http://www.lightimpressionsdirect.com/servlet/OnlineShopping

LexJet Direct

Great place to buy inkjet printers, paper and ink. Call Carey.

http://www.lexjetdirect.com/lexjet/

Amazing Mail

This company will cost effectively print, address, stamp, and mail postcards on very short notice.

http://www.amazingmail.com

Impact Images

Source for plastic bags for storing, displaying, and delivering photographic prints.

http://www.clearbags.com

Marathon Press

Inexpensive photo stationery for wedding and portrait photographers. They also provide marketing and website programs.

http://www.marathonpress.com

Black Book

A place to advertise your photo services to art directors.

http://www.blackbook.com

Buy.com

My favorite place for buying any electronic item that I can't find at B&H Photo.

http://www.buy.com

Miscellaneous Photo/Business Websites

Photofocus Magazine
http://www.photofocus.com

Dukeofdigital Blog
http://www.dukeofdigital.com

Editorial Photographers
http://www.editorialphoto.com

Small Business Administration
http://www.sba.org

Stock Photo Price Calculator
http://photographersindex.com/stockprice.htm

Photo Attorney.com
http://www.photoattorney.com

NOTE: If you have suggestions for sites that we should note in the second edition of this book, please mail them to:

Olympic Mountain School Press
Sales Book Ideas
P.O. Box 1114
Gig Harbor, WA 98335

NO EMAIL PLEASE!

This book is also a workshop.

Through the Olympic Mountain School of Photography, Scott Bourne teaches photographers how to sell and show their work.

Private consultation is available as well as group instruction. To find out how to attend one of Scott's workshops, visit the Olympic Mountain School of Photography website at www.cameraclass.com, call 253-858-4448, or write to us at:

OMSP – Scott Bourne
P.O. Box 1114
Gig Harbor WA 98335-1713
USA

ABOUT THE AUTHOR

Scott Bourne is an award-winning, professional photographer who earns his living making and selling photographs.

While his current passion is wildlife photography, Bourne's photographic career started in the early 1970s as a stringer covering motor sports for Associated Press in Indianapolis. Since then, he has shot commercial, portrait, wedding, magazine and fine art assignments.

Bourne regularly teaches and speaks about a variety of photo and media-related subjects and is a pioneer in the digital imaging field. He has appeared on national television and radio shows and his photos have appeared in newspapers, magazines, calendars, and books. Bourne is also editor of Photofocus Magazine (www. photofocus.com), one of the most highly visited photography e-zines on the web.

In addition to his photographic assignment work, Bourne is the Executive Director of the Olympic Mountain School of Photography

Scott's portrait photo courtesy Patrick Reeves

Scott's portrait photo courtesy Patrick Reeves

INDEX

Book Order Form

Would you like additional copies of this book? If so, please use this order form.

ADDRESS:
Please send the form along with your payment to:

Olympic Mountain School Press
P.O. Box 1114
Gig Harbor, WA 98335

Please send me _____ copy(s) of the book: *88 SECRETS TO SELLING & PUBLISHING YOUR PHOTOGRAPHY.*

Price: $12.95 - U.S. funds. PLUS SHIPPING!

NAME: _____

ADDRESS: _____

CITY/STATE/ZIP: _____

TELEPHONE: _____

E-MAIL ADDRESS: _____

(Sorry USA residents only please)

Please add nine percent (9% = $1.17) sales tax for each copy if you are a Washington resident. All books are shipped via US Mail.

Please add $3.95 shipping and handling for the first book and $1.50 for each additional book shipped to the same address.

We accept check, money order *made out to OMSP*. We also accept Pay Pal made payable to sales@mountainschoolpress.com.

While most books will be shipped within one week, please allow up to four weeks for delivery. Thank you.